Mid Sussex

Suffragists

Frances Stenlake

Copyright © 2009 Frances Stenlake

Mid Sussex Suffragists

ISBN 978 1 906509 10 1

First published 2009

Foreword

While it is hoped that this account will be of interest in its own right, it has been written as a postscript to two earlier books: *From Cuckfield to Camden Town, the story of artist Robert Bevan* (Cuckfield Museum 1999), and the much-expanded and full-colour monograph, *Robert Bevan, from Gauguin to Camden Town* (Unicorn Press 2008). Now, 100 years after Edith, the artist's younger sister, invited friends and sympathisers to an inaugural suffragist meeting at Horsgate, the family home built by her banker father in Cuckfield, it is her turn to have her story told. When Richard Bevan, 'Cuckfield's leading citizen', pressed upon his fellow townsmen the idea of building the Queen's Hall, he could not have imagined that ten years later his daughter would book the venue for the first public meeting of the Cuckfield Women's Suffrage Society, and that she would subsequently arrange the visit of, arguably, the most important historical figure ever to speak there: Millicent Garrett Fawcett.

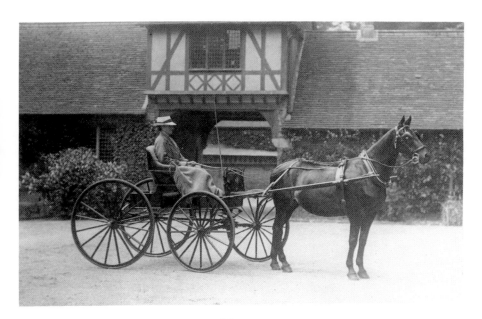

Edith Bevan at the entrance to Horsgate

Contents

1 Like Minds in London	5
2 Over Tea at Horsgate	10
3 Speeches in Red, White and Green	14
4 Constitutional Electioneering	17
5 Now Cuckfield and Central Sussex	21
6 Star Turns	24
7 Sweated Industry	35
8 Continuing Press Coverage	44
9 The Brighton Road Pilgrimage	57
10 Women's Handicrafts	72
11 Women's Lecture Programme	76
12 Pulling out all the Stops: Millicent Garrett Fawcett in Cuckfield	81
13 The End of the Horsgate Era	85
14 The East Chiltington Epilogue	89
Footnotes	93
Acknowledgements	95
Bibliography	96

Abbreviations used:

CDWSS Cuckfield and District Women's Suffrage Society
CCSWSS Cuckfield and Central Sussex Women's Suffrage Society
CSWSS Central Sussex Women's Suffrage Society
EGWSS East Grinstead Women's Suffrage Society
MST Mid Sussex Times
NUWSS National Union of Women's Suffrage Societies
WFL Women's Franchise League
WSPU Women's Social and Political Union

1

Like Minds in London

Despite her privileged family circumstances, Edith Bevan, founder of the Cuckfield and District (later Central Sussex) Society for Women's Suffrage, had, good reason to fly the feminist flag. She was born in 1869, the sixth and youngest child of wealthy parents from Brighton who, just a few years earlier, had bought themselves into the top stratum of Cuckfield society. Her father, Richard Bevan, ran the Brighton Union Bank, to become part of Barclays. Barclays' half-yearly dividends were announced in the *Mid Sussex Times* (hereafter *MST*), the local weekly newspaper published in Haywards Heath; in January 1913 Barclays could boast that its lease of new shares had been considerably over-subscribed. Edith's mother was the daughter of Edward Polhill, whose financial position qualified him for membership of Hove's Brunswick Town Commission.

By 1865, Richard Bevan, making use of the recently-built railway in order to commute daily, had established his family in Cuckfield. He had purchased over 100 acres from the Sergisons, one of the two major landowning families in Cuckfield, in order to create his Horsgate estate just to the east of the town. Here he built a large Victorian Gothic country house (now owned by the Downland Housing Association, with Court Meadow Special Needs School situated in the former kitchen garden). The Bevan children enjoyed a lifestyle appropriate to the landed gentry. The family kept its own horses and harrier hounds, and Edith continued to attend Hunt meetings even after her four brothers were no longer riding to hounds locally.[1]

Edith received schooling at Horsgate, with her brothers Robert and Hubert, from a resident Oxford graduate. According to her niece, who was to spend considerable periods of time with her aunt, this

young man, as he was leaving, dared to ask Richard Bevan for permission to marry the beautiful Edith. Being refused, he subsequently wrote Edith a letter. This was kept from her by her parents who later learned that her would-be suitor had inherited a title and a large estate. Edith's two elder brothers had gone to Oxford, in preparation for following their father into the bank, and she longed be educated likewise, but this too was denied her. She eventually persuaded her parents to allow her to undertake a five-year nursing training in London, and spent much of the first year scrubbing floors and performing other menial tasks to which she would have been quite unaccustomed. During her final year as a trainee nurse, she was recalled to Horsgate to care for her ailing mother and run the household. After her mother died in 1906, Edith was obliged to remain at home to look after her father until he died in 1918, by which time she was 49.

According to Edith's niece, Edith met Emmeline Pankhurst while in London and joined the Women's Social and Political Union, formed in 1903. Certainly, while she was training, there would have been a great deal of discussion of women's suffrage, particularly among members of the nursing profession. The Society of Registered Nurses and the Nurses' International Congress were listed by Millicent Garrett Fawcett as among other societies which had repeatedly petitioned Parliament, or passed resolutions, asking for a measure of women's suffrage.

In February 1906, the first demonstration was mounted by the WSPU in the streets of London, when 3,000 women gathered in Whitehall to watch the King pass in procession to open Parliament, before assembling in the Caxton Hall, Westminster, for a public meeting addressed by Christabel Pankhurst, daughter of Emmeline. Suffrage campaigners now had to decide whether to allow themselves to be incited to militancy by the Pankhursts or to keep to constitutional methods of persuasion. It was presumably at this time that Edith Bevan switched her allegiance to Millicent Garrett Fawcett and the National Union of Women's Suffrage Societies.

Millicent Garrett Fawcett, the younger sister of Elizabeth Garrett Anderson, was the widow of Henry Fawcett, the blind Liberal MP for Brighton, who had first presented a suffrage petition to Parliament in 1868. The Municipal Franchise Act of the following year had given women ratepayers the right to vote in local elections and enabled them to serve as Poor Law Guardians, and Millicent Garrett Fawcett had been holding meetings in Brighton to demand Parliamentary suffrage since the 1870s. In 1897 she formed the NUWSS, consolidating societies already in existence in Manchester, Bristol, London and Edinburgh, and Birmingham. Its Executive Committee was made up of some of the most distinguished women in England. Many were Non-Conformist and already working to improve the position and conditions of women as regards higher education, industrial employment, and local government regulation.

The election of a Liberal government in 1906 encouraged the NUWSS to increase its efforts to campaign using constitutional means. However, although the majority of MPS in the new House had pledged support, women's suffrage had not been a major election issue and other matters took priority. Moreover, Asquith, who succeeded Sir Henry Campbell-Bannerman as Prime Minister in 1908, was notoriously opposed to giving women the vote. The NUWSS therefore, like the WSPU, developed new methods of campaigning: rallies, processions, pictorial leaflets, posters, postcards, banners – all recommended by its journal, the *Common Cause*.[2]

Early in 1907, 'ladies of title and distinction joined in a procession through muddy streets on a cold February afternoon, undaunted by the rain and by the jeers of amused spectators'. (*Times* 11 February 1907) This was the Mud March, from Hyde Park to the Exeter Hall, a huge Saturday afternoon event organised by the NUWSS, to take place simultaneously with a rally in Trafalgar Square, immediately prior to the opening of Parliament on 9 February. It was the largest suffrage demonstration yet held, representing organisations from all

over the country, and the NUWSS was helped by the Artists' Suffrage League, the first of the suffrage societies of professional women, and founded just the previous month to produce postcards, leaflets, and banners for both demonstrations and meetings.

Nearer to home, the Brighton and Hove Women's Franchise Society, first formed by the Fawcetts in 1872, had been revived in 1906 as a local branch of the NUWSS. Flora Merrifield became Secretary. Her parents, a barrister and a writer, had, with Henry and Millicent Garrett Fawcett, formed the original Brighton branch of the NWSS in 1872. Her sister, a classics lecturer, had married Professor Verrall, also from Brighton, and brother of Marian Verrall of The Lydd, West Hoathly, who was to become Chairman of the Cuckfield and Central Sussex Women's Suffrage Society.

Back in Cuckfield, Edith would have followed these developments with particular interest, while all too aware of the constraints imposed by her family's social status. Since the 1860s Richard Bevan had maintained a high profile on two fronts: professionally, in Brighton, and in Cuckfield as his adopted town's 'leading citizen', taking charge quite comprehensively. With his contributions, both managerial and financial, to local organisations and events, indigenous gentry and aristocracy could hardly compete.

The Bevan family was closely associated with Cuckfield's Holy Trinity Church. Richard Bevan had been a particular friend of the dearly-loved Canon Cooper, Vicar and Cuckfield historian, who died in August 1909. Richard and Edith were among those at his graveside,[3] and Richard chaired the meeting held to discuss an appropriate memorial.[4] From at least the beginning of 1910 until late 1916 Edith Bevan was a Girls' Sunday School teacher, in the company of suffragist recruit Miss May Caffyn. Her closest suffragist friends, Miss Chute Ellis and Miss Susan Armitage, were also devout churchgoers and regularly entertained Canon Fisher, Canon Cooper's successor, to tea. However, nothing relating to the

suffrage campaign is found in the Cuckfield Parish Magazines of this period.

Richard Bevan's involvement with the Church reflected a genuine interest in the propagation of the Christian faith. He was a keen subscriber to the local non-denominational Bible Society. Its president was Miss Katherine Gray of Warden Court, and other members were the Reverend Maddock, pastor of the Cuckfield Congregational Church, and the Payne family, all active suffragists. The Payne family had long been associated with the Congregational Church and several other leading suffragist families were Congregational Church members. These included the Cleares, of Corelli, Broad Street, who were related to the Paynes, and the family of William Stevens JP, of the well-known Brighton solicitors' practice (the original of Stevens Son and Pope of Burgess Hill). The Stevens family lived at Garnalds, Copyhold Lane, and, as leading local Liberals as well as Congregationalists, were friends of the Payne family.

Edith was compensated for disinterest on the part of her own Church by a sympathetic attitude on the part of the *MST*. That it would follow her undertaking was indicated by its reporting of suffragist events in London during the period leading to the formation of the CDWSS. Under the headline *Right to Vote*, the *MST* reported the march on 13 June 1908 through the streets of the West End to a rally at the Albert Hall. Mrs Fawcett was to claim that participants numbered 15,000. Every rank of society was represented and the women, in many cases accompanied by male sympathisers, had arrived by train from all parts of Great Britain and Ireland. They were joined by contingents from abroad, and professional women, for example nurses, in appropriate uniform, contributed to the pageantry. Fifteen bands played.

> The crowd of spectators on the Embankment, where the processionists assembled, and along Northumberland Avenue and Piccadilly to Hyde Park Corner, was terrific, and everywhere hearty cheers were raised.

Although the procession included many men, the ladies insisted on carrying their banners and flags themselves. A notable banner was that of the Women's Freedom League, with a picture of Holloway and the inscription, *Stone walls do not a prison make.*

Mrs Fawcett LLD opened the mass meeting, declaring that the demonstration seemed to bring within a measurable distance the day of their final triumph. Lady Henry Somerset (of Reigate Priory, and President of the British Women's Temperance Movement), although not in accord with many of the methods recently used, said that they were merely asking for justice. Dr Anna Shaw from Philadelphia, Mrs Despard, President of the Women's Franchise League, Mrs Hodgett, President of the Women's Co-operative Guild, and Lady Frances Balfour (President of the London Society for Women's Suffrage) also spoke.[5]

1909 saw the escalation of militant activity, with the start of stone-throwing, resultant imprisonment, and hunger strikes. The *MST* reports of these incidents were kept brief. On 6 April, for example, it was merely stated that as a result of suffragette disturbances outside the Houses of Parliament, nine women had been charged with wilfully obstructing the police, and all had elected to go to prison. The formation of the Women's Anti-Suffrage League that year, with its figurehead the best-selling novelist, Mrs Humphrey Ward, received little attention.

2

Over Tea at Horsgate

It is difficult to imagine Richard Bevan, who had denied his younger daughter both marriage and a professional career, as a supporter himself of women's suffrage. Perhaps he had become so dependent on Edith as companion and mistress of the house that he felt obliged

to humour her by allowing the inaugural meeting of the CDWSS to be held at Horsgate.

At this meeting Edith Bevan took on the position of Honorary Secretary.[6] She would have been well aware of what her new role would entail. The *Common Cause*, in urging its readers to form local branches, offered plenty of advice: for example, as regards the display, for maximum effect, of the NUWSS colours of red, white and green. All members should wear the official red, white and green badges. Each branch should provide itself with matching flags and banners, and decorate every hall in which it was to hold a meeting. For afternoon 'drawing room' meetings, red and white flowers should be purchased. Stewards at all meetings should endeavour to wear red, white and green. All advertising and propagandist posters and handbills should be printed in these colours.[7]

An important local inspiration of the nascent CDWSS was Mrs Ann Payne. She had come, with her husband, to live at Hatchlands (later a school) in Broad Street, Cuckfield, in the mid-1870s. The couple had previously lived at Forest Hill, south London where she had become a supporter of the women's suffrage movement. A member of the Cuckfield Congregational Church, and President of the Cuckfield, Haywards Heath and Wivelsfield Women's Liberal Association, she was persuaded, when the Local Government Act of 1894 created the Urban District of Cuckfield, to represent the Cuckfield Urban District Council on the Poor Law Board of Guardians for the Union of Cuckfield and neighbouring parishes. She thus became involved in the administration of the Union Workhouse in Hanlye Lane and in the placing of children with foster parents. She was elected to the first Committee of the Eliot Cottage Hospital when this was established in Haywards Heath in 1906 and was appointed a Visitor of the Pupil Teachers' Centre in the town.

Mrs Payne had one son and three daughters. Eldest daughter Edith, sharing her mother's commitment to public service, had become by 1909 the only woman member of the Cuckfield Urban District

Council. She was a close friend of Edith Bevan, whose father was Treasurer of both the CUDC and the Board of Guardians. At Mrs Payne's funeral in December 1909, Edith and Richard Bevan were among the many prominent local figures at the graveside, and their floral tribute joined wreaths from the Congregational Church, the Women's Liberal Association, the Board of Guardians, and the CWSS.[8]

Six months earlier, at the beginning of June, although too ill to attend herself, Mrs Payne had sent wishes of encouragement to a Saturday afternoon meeting arranged by the two Ediths at Cuckfield's Queen's Hall, built a decade earlier at the instigation of Richard Bevan and furnished largely by donations from the Bevan family. The purpose of the meeting was 'to form a Society for the attainment, by constitutional methods, of the franchise for women'. Taking place a week after a WSPU meeting at Burgess Hill, the Cuckfield event attracted so many local figures that 'a large and influential membership' was promised. The Society was to be affiliated to the NUWSS, and Edith Bevan invited subscriptions from Cuckfield, Haywards Heath, Lindfield and the surrounding area. 'The membership fee is 3 pence, but a larger sum will not be refused, as with an ample supply of funds the Society will be the better able to make its existence felt.'

Among leading suffrage figures in attendance was Marie Corbett, whose husband, Charles Corbett, had won the East Grinstead seat for the Liberals in 1906, narrowly overturning the usual Conservative majority. The Corbetts lived at Woodgate (now Cumnor House School), Danehill, on the large estate he had inherited. They were founder members, with Lady Frances Balfour, of the Liberal Women's Suffrage Society. Marie Corbett, with Muriel, Countess de la Warr, was to form the East Grinstead Women's Suffrage Society in May 1911 and Charles Corbett formed a branch of the Men's League for Women's Suffrage there in 1913. Their two daughters, Margery and Cicely, were also very active in the cause, Margery

having become Organising Secretary of the NUWSS in 1907, and Cicely working as a campaigner against sweated labour.

The first guest speaker, Dr Flora Murray, explained that women suffragists were asking for the vote on the same terms as it had been granted to men, that is, not for all women, since it had not yet been granted to all men, but for those who paid rates and taxes, who were property owners, occupiers or lodgers. With Parliamentary votes women would be able to improve the social status of industrial and professional women, and make more equitable and just the laws dealing with women and children. Following standard procedure at such meetings, she ended her speech by submitting an apposite resolution. This was seconded by Mrs Francis, of Brighton, who claimed that despite significant Parliamentary, professional and ecclesiastical support for the extension of the franchise, women, as a whole, had not done their share in supporting the leaders of the women's suffrage movement. Yet discrepancies in rates of pay for men and women led to many women being 'sweated to death'. For a silk blouse, sold for more than a guinea, the woman who made it might be paid only 2 ½ pence. Women should think of their sisters who were less fortunate than themselves.

As was customary, the vote of thanks to the speakers took the form of a concluding, approbatory speech: on this occasion by Marie Corbett, seconded by Katherine Gray, herself a professional woman. She and Miss Priestman ran the Young Ladies School at Warden Court.[9]

The *MST* account of this inaugural event set the pattern for the reporting of the many meetings organised by Edith Bevan in the Mid Sussex area during the next five years. The list of those attending would, on each occasion, have befitted a society column, and the proceedings always closed with the serving of tea. The verbatim recounting of speeches indicates that the reporter was issued with a prepared script, into which he could interject evidence of audience response: 'applause'; 'laughter'; 'a loud whisper of "Rot!"'

3

Speeches in red, white and green

The repetitive nature of suffragist speeches was such that the Chairman of a meeting might admit to being tired of hearing about the suffrage question and wishing that they did not have to keep discussing it. The main arguments of a suffragist speech were perennial and predictable. The first point to be emphasized was always that the NUWSS campaign was constitutional and non-violent.

> The NUWSS never wavered in its conviction that constitutional agitation was not only right in itself, but would prove far more effective in the long run than any display of physical violence, as a means of converting the electorate, the general public, and, consequently, parliament and the government, to a belief in women's suffrage. (Millicent Garrett Fawcett)

It was equally important, particularly in Central Sussex, to stress that the campaign was non-party.

> What the NUWSS aimed at was the creation in each constituency of a women's suffrage society on non-party lines, which should by meetings, articles, and educational propaganda of all kinds create so strong a feeling in favour of women's suffrage as to make party managers on both sides realise, in choosing candidates, that they would have a better chance of success with a man who was a suffragist than with a man who was an anti-suffragist. (ibid.)

What the suffragists were seeking was actually quite limited: the vote for women as given to men. This would amount to the enfranchisement of relatively well-off single women (spinsters or widows) only, those who had a property qualification in their own right: were property owners or paid a certain level of rent. The demand was not for universal suffrage, so there was no risk of

women becoming a majority, although they outnumbered men in the population. Within official NUWSS policy there appears to have been some ambivalence as regards two points: votes for married women, and the right of women to stand as Parliamentary candidates. Some speakers went as far as to deny that they were asking for either of these, at least for the time being.

A strong argument was that the Municipal Franchise Act had given single women ratepayers and property owners the right to vote, when these were created, for School Boards, Poor Law Boards of Guardians, and local Councils. Millicent Garrett Fawcett pointed out 'the absurdity of the law which allows a woman to be a Town or County councillor, or eve a mayor, and in that capacity the returning officer at a Parliamentary election, but does not permit her to give a simple vote in the election of a member of Parliament'.

Much was made of the increasing part played by women in the industrial and economic life of the country, whether running their own businesses and therefore paying the same rates and taxes as men, or being exploited and underpaid as sweated labour.

Although the granting of the vote to the latter was not yet envisaged, the element of idealism in the NUWSS creed was expressed in its speakers' confident assertions that the enfranchisement of qualified women would lead to a more moral society and greater social justice. Women thus privileged would certainly seek to use their votes to improve the lot of their enslaved sisters. Moreover, their view of their domestic, as well as social, role, would be enhanced. 'To give full citizenship to women deepens in them the sense of responsibility, and they will be more likely to apply to their duties a quickened intelligence and a higher sense of the importance of the work entrusted to them as women.' (op. cit.)

It was claimed that fairer laws would be made, pertaining not only to employment, but to such matters as divorce, if legislation were drawn up by women working with men.

The point was made that while the throne could be occupied by a woman, in being excluded from the Parliamentary franchise, women were grouped with idiots, lunatics and felons. This had not prevented political parties from calling on their practical support.

> The formation of women's political associations was encouraged by party leaders of all shades of politics. There is probably not a single party leader, however strongly he may oppose the extension of the suffrage to women, who has not encouraged the active participation of women in electoral work. The Liberal party issues a paper of printed directions to those who are asking to do electoral work in its support. The first of these directions is, *Make all possible use of every available woman in your locality.*
>
> Suffragists contend that a party which can do this cannot long maintain that women are by the mere fact of their sex unfit to be entrusted with a Parliamentary vote. (op. cit.)

Countries which had already granted women the vote were commended.

> New Zealand and Australia have, since they adopted women's suffrage, inaugurated many important social and economic reforms, among which may be mentioned wages boards – the principle of the minimum wage applied to women as well as to men – and the establishment of children's courts for juvenile offenders. They have also purged their laws of some of the worst of the enactments injurious to women.
>
> The evidence favourable to the working of women's suffrage is overwhelming, and is given not only by men who have always supported it, but by those who formerly opposed it, and have had the courage to acknowledge that as the result of experience they have changed their views. (op. cit.)

Much time was spent by NUWSS speakers refuting the arguments of the 'Antis': that voting was unnatural and unfeminine; that women

lacked physical force, could not fight for their country and therefore were not due the vote; that women lacked both education and political capacity; that women did not want the vote.

> However benevolent men may be in their intentions, they cannot know what women want and what suits the necessities of women's lives as well as women know these things themselves...

> One most effective reply has been made by the suffragists to the allegation of their opponents that women do not desire their own enfranchisement. Between the autumns of 1910 and 1911 more than 130 local councils petitioned Parliament in favour of passing without delay the Women's Suffrage Bill, know as the Conciliation Bill. These councils comprise those of the most important towns in the kingdom. (op. cit.)

4

Constitutional electioneering

Throughout the summer of 1909, while the CDWSS was still in its infancy, readers of the *MST* were reminded of militant suffrage activity: a suffragette's unlawful entry into the House of Commons, and another WSPU meeting at Burgess Hill, chaired by Burgess Hill vicar, the Rev. Pinney, at which the fearsome Miss Helen Ogston spoke for the second time.[10] The previous December, after interrupting Lloyd George's speech to the Women's Liberal Federation at the Albert Hall, she had used a whip against stewards who attempted to eject her from the meeting.

Constitutional campaigning for women's suffrage was the theme at the Burgess Hill Women's Liberal Association summer garden party in July,[11] and it was Mrs Cleare, as Secretary of the Cuckfield, Haywards Heath and Lindfield Women's Liberal Association, who

17

chaired a public meeting held in Cuckfield by the CDWSS three months later. 'The increasing interest being taken in the question of Women's Suffrage' was reflected in 'a large attendance of persons in all stations of life'. 'We noticed a good number of men present, but they were too shy to occupy front seats, preferring to stand afar off.' Mrs Cleare admitted that it was almost impossible to say anything fresh about a subject that had been 'before the public for so many years' but she emphasised that the Women's Suffrage Society was non-political and welcomed men as members because it was recognised that women could not get the vote without their help. Mrs Francis made 'another fluent speech – it is really remarkable how the words roll off a woman's tongue!' - and 'gave the Anti-Suffrage League a sound knock'. She was followed by Mr H Baillie-Weaver LLB, of the Men's League for Women's Suffrage, 'whose fine presence and thorough grasp of his subject made him a favourite with all'. There was no reason to fear that women would discard personal Party allegiances and combine to oust men, and women were not asking that they should have the liberty to sit in Parliament.[12]

Local developments continued to be seen against the background of national events. The NUWSS felt obliged, as it had the previous autumn, to publish 'its deep and abiding disapproval of the tactics of violence and petty annoyance' in a letter to the *Times* of 3 October signed by Millicent Garrett Fawcett and Frances Balfour, and in notices in the local press.

> The Council of the NUWSS strongly condemns the use of violence in political propaganda, and being convinced that the true way of advocating the cause of Women's Suffrage is by energetic, law-abiding propaganda, reaffirms its adherence to constitutional principles, and instructs the Executive Committee and the Societies to communicate this resolution to the Press.
>
> While condemning methods of violence the Council of the NUWSS also protests most earnestly against the manner in which the whole suffrage agitation has been handled by the responsible Government.

The *MST* too, however strongly it appeared to support this constitutional approach, implied that some sympathy could be felt for the strength of feeling leading to militant action, and the harsh treatment of female perpetrators. When Emily Davison, who had already been imprisoned four times that year, was sentenced to hard labour at Strangeways and barricaded herself into her cell, she was 'hosepiped' through the aperture in the door until the water level rose so high that she had to be released. The *MST* account, pointing out that this action was taken in the middle of a winter night, emphasizes the inhumanity of the practice.[13]

Women's suffrage was still not a priority for the Liberal government in late 1909. When Lloyd George's April Budget, which would have resulted in increased taxes on wealth and property, was thrown out by the House of Lords, demands for the reform of the second Chamber led to the calling of a General Election for January 1910. The NUWSS published its 'election manifesto' in the *Times* of 18 December 1909, pointing out the unprecedented prominence of women's suffrage as an election issue.

> For the first time in the history of our movement the political campaign preceding a general election has opened with important declarations from the Prime Minister and leading members of his government on the subject of women's suffrage. The Prime Minister, after indicating his own continued opposition to women's suffrage, said, "It is clearly an issue in which the new House of Commons ought to be given an opportunity to express its views."
>
> It accordingly becomes in the highest degree important to fill the new Parliament as far as possible with men, whether Conservative, Liberal or Labour, who are sincere women's suffragists. Women's suffrage is not, and never has been, a party question.
>
> The executive committee urges most emphatically upon all the societies in the union and upon all sympathisers not yet included in the union, to work solely for the return of men, to whatever party they may belong, who are publicly pledged to remove the electoral disabilities of women, and also to resist the election, by all constitutional means in their power, of the enemies of women's enfranchisement.

Accordingly, 1910 opened with branches inviting voters to sign a petition to be presented to Parliament asking that women be given the vote on equal terms with men. In Cuckfield and Haywards Heath this would mean canvassing up to 1,300 voters and Edith Bevan appealed for help.[14] In the event, as well as petitions being sent round, voters were invited to sign the petition at polling stations, and nearly 800 signatures were obtained. 'It is encouraging to find that most of the electors who have been interviewed are ready to acknowledge the justice of giving votes to women and to show their sympathy to the cause in this practical way.' The outcome of the election was another Liberal government but with a much reduced majority. The East Grinstead seat was regained for the Conservatives by Henry Cautley, who wrote to Edith Bevan to say that he would have much pleasure in presenting the petition to the House. Nationally, over a quarter of a million signatures were obtained and over 320 members of the new House of Commons pledged support.

In Brighton pre-election campaigning, on the occasion of a visit by Prime Minister Asquith, had taken a more dramatic form.

> There was, after all the extraordinary precautions and searches, a suffragette in the Dome. Others had been turned out of the organ loft during the afternoon. They had been there for 24 hours and were as black as sweeps after their all-night vigil in the dust and grime. But their ejection before the meeting had not completed the tale of their resourcefulness. When the Prime Minister was about halfway through his speech, at the moment when a hush of expectancy had fallen upon the audience, a shrill voice broke in suddenly with the words, "What about the women, Mr Asquith?" It was discovered that a slim youth in a lounge suit and overcoat was a woman. She was treated quite gently but she looked scared.

As if to deride this instance of cross-dressing, a display advertisement on a subsequent page, under the slogan *Votes For Women*, claimed that 'the big demand on the part of every woman' was a demand that could very easily be satisfied – by the 'personal wear or adornment' stocked by Prince's of Hurstpierpoint.[15]

5

Cuckfield and Central Sussex

Soon after the Election, at a well-attended At Home, held by the Haywards Heath branch of the NUWSS in the Co-operative Hall, 'ladies of independent means were present, and their less fortunate sisters, who have to look at a shilling before they spend it, were seated beside them'. The latter included a few mothers who brought their babies and these were so good that 'one would not have believed that they were in the room'. Miss Pickworth, of the Brighton and Hove branch, was in the chair, supported by Mrs Jane Strickland of the Bexhill, Hastings and St Leonard's branch, Miss Spooner (of Red House, Muster Green) and Edith Bevan – 'ladies who have put their heart and soul into the Women's Suffrage Movement'. The usual assurance was given that the NUWSS was non-militant and non-party, and it was announced that Cuckfield and Haywards Heath together now had over 100 members. When Mrs Strickland spoke, 'all that she uttered was good commonsense'. Her mixed metaphors must certainly have conveyed a sense of energy: 'They had reached the last lap, and all hands were wanted at the pump to get the Women's Suffrage ship into port.' [16]

The following month, February 1910, a women's suffrage measure was drawn up by an all-party Conciliation Committee of 54 MPs. This Conciliation Bill was based on the 1869 municipal franchise. It was a compromise: it would enfranchise single women occupiers and householders, amounting to 1 ¼ million women; the number of men who had the vote was 7 ½ million. Although it would not grant equality with men, it received general suffragist support.

Keeping the Torch Alight at Haywards Heath was an apt headline for a report of a meeting in Haywards Heath Public Hall in March,

organised by the CDWSS, and chaired by Mr Brunel, of the Sussex branch of the Men's League for Women's Suffrage. Speeches were made by Mrs Francis and Marian Verrall. 'Two more interesting speakers it would be difficult to find. They have a charm of manner which rivets attention, and their happy gift of expression forces one to see the justice of the claim they make on behalf of their sex.' Mrs Francis used her 'ringing tones' to refute the argument that women took no interest in politics, by reminding her audience of the Women's Liberal association and the (Conservative) Primrose League at election time. She was supported by her husband who spoke on the international aspect of the women's suffrage question. Mr Brunel contended that 'the intellect of Great Britain was solid for women's suffrage' and appealed to men to come forward and help. Edith Bevan would be happy to receive membership subscriptions. Thanks were voted by Miss Spooner and Miss Mertens, of Whitmore, Cuckfield, whose father, the Rev. Mertens, had been Headmaster of St Saviour's College, Ardingly, and was now Assistant Clergyman at Holy Trinity. Throughout the evening pianoforte and violin selections were played by Miss Cleare and Miss L Shipley.[17]

'Another of those homely meetings which have helped to popularise the women's suffrage movement' was reported at the beginning of May. Held in the Co-operative Hall, chaired by Miss Spooner, who had accompanied Edith Bevan to the At Home for representatives of 130 NUWSS branches hosted by the London Society for Women's Suffrage at the Hotel Great Central, Marylebone, in March, and had been able to report there that membership of the Cuckfield and Haywards Heath and District continued to increase. It now numbered 149, a group of 16 having been started at Hurstpierpoint the previous day. More supporters were wanted in Burgess Hill, where Miss E Stevens, a relative of William Stevens of Cuckfield, had been advocating women's suffrage at the Women's Liberal Association, and in Hassocks, Horsted Keynes and other districts. A summer campaign in the villages was being planned. Marie Corbett spoke of the prominent part women were now playing in municipal politics, in

the professions and in the arts. 'Further, they were taking an active part in various kinds of games and sports, learning the value of combination and unity, and how to take success and how to take a beating.'[18]

The first annual meeting of the CDWSS, in the Queen's Hall, was reported in detail. It was chaired by Edith Payne, accompanied on the platform by Edith Bevan, Mrs Strickland and Mrs William Stevens. The verbatim transcription of the committee's review of the fourteen months since the preliminary meeting at Horsgate in April 1909 amplified earlier press reports of its activities. Total membership was now 166. In addition to the two public meetings and seven members' meetings, the suffrage play, *Man and Woman*, had been performed by Mr and Mrs Francis and Company in the Queen's Hall in December 1909 and had been 'greatly appreciated'.

> The General Election in January gave great impetus to our work. The Voters' Petition afforded a unique opportunity for advertising the society and placing our claims for the franchise prominently before the electorate. To enable us to carry out an effective campaign an election fund was raised, expended in providing hoardings with large picture posters and a monster reproduction of the petition, and supplying quantities of leaflets in the district explaining the objects of our Society. On polling day, petition workers manned polling stations at Haywards Heath, Burgess Hill, Hassocks, Hurstpierpoint, East Grinstead, Horsted Keynes and Crowborough, and petitions were taken round at Cuckfield, Crawley Down and West Hoathly. 778 signatures were obtained. Helpers from London, Tunbridge Wells, Eastbourne and Brighton assisted, and in return Miss Bevan, Miss Goldring and Miss Mertens went to Eastbourne to help there. Failing in their endeavours to present the signatures personally by deputation to Mr Cautley, your committee had to content themselves with a request by letter that he would present it to the House of Commons. A reply had been received from Mr Cautley stating that he had done so. . .
>
> During the year our society has affiliated to the National Union of Women's Suffrage Societies and was represented by Miss Bevan and Miss Spooner at the annual Council Meetings held in London in March, at which various momentous decisions were arrived at affecting the present organisation and future policy of the Union. We have also joined the Sussex, Surrey and Hants Federation.

> We hope that the ensuing year will see a still greater development of our work in arousing the women of this county and constituency to a sense of their disenfranchised condition, and to an earnest determination to have our claims for justice brought before Parliament without delay.

A plea was made for assistance in preparing the ground for the summer campaign in the outlying villages by canvassing and distributing literature. It was at this meeting that it was agreed, on the proposition of Katherine Gray, to alter the name of the Society to the Cuckfield and Central Sussex Women's Suffrage Society.

In June, Millicent Garrett Fawcett had circulated all NUWSS branches, urging meetings and demonstrations in support of the Conciliation Bill, which passed its first reading on 14 June. Mrs Strickland urged participation in a further demonstration to be held in London very shortly, on 9 July, to try to persuade Mr Asquith to allow a second reading of this Bill on 11 July. Following the customary vote of thanks to the speakers, special thanks were accorded to Edith Bevan 'for carrying out her secretarial duties in so painstaking a manner', and 'tea and a pleasant chat followed'.[19]

6

Star Turns

Although the Conciliation Bill passed its second reading on 12 July, the Government prevented its progress into law by dissolving Parliament. The CCSWS was undaunted.

> All people who admire thoroughness must say a good word for the Cuckfield and Central Sussex Women's Suffrage Society. Its officers are

so firmly convinced that the cause they are championing is deserving of the support of all womanly women that they are doing all in their power to win them over to their way of thinking and to get them to take their stand boldly under the Suffragist banner.

Thus began the report of a meeting organised by Edith Bevan in the grounds of the Congregational Hall in Horsted Keynes, and graced by veteran suffragist, Mrs Louisa Martindale, of Cheeleys, who provided a 'dainty tea'. She had been living in Horsted Keynes for several years and had instigated the building of the Congregational Hall and Institute, and the installation there of Britain's first woman pastor, Harriet Baker, in 1907. She was the author of several pamphlets on women's emancipation, and was particularly associated with the education of girls. Before coming to Horsted Keynes she had lived in Brighton, where she had been President of the Women's Co-Operative Guild and of the Women's Liberal Association, setting up the organisation, The Practical Suffragists, to work within the National Women's Liberal Federation. As a member of the Central Council of the NUWSS, she was involved in the reviving of the Brighton and Hove branch in 1906 and had worked with Flora Merrifield.

Flora Merrifield, brought up, like the Corbett sisters and Edith Payne, to be a suffrage campaigner, could confidently take the chair. She read out a letter from Marie Corbett, a close friend of Mrs Martindale, lamenting that Henry Cautley had voted against the second reading of the Conciliation Bill. Nevertheless the second reading on had been carried by a majority of 109 and Mrs Francis reviewed the ensuing debate in the Commons. They were grateful to Labour MP Philip Snowden, Vice-President of the Men's League for Women's Suffrage, for keeping their flag flying. They must do their best to get the franchise this session, and some of them were going to give up their holidays to work for the cause. The CCSWSS was looking for recruits in Horsted Keynes to bring membership up to 200. Subscriptions remained at 3 pence. Miss Meyer, of Birch Grove, agreed to become Hon. Secretary, and Mrs Percy Holyoake, of Leightoncote, took on the job of Hon. Treasurer.[20]

A month later, the Horsted Keynes branch was 'going strong, having the support of many of the leading ladies of the neighbourhood' and was invited by the Rev. Maycock to hold a public meeting in the Parish Room. To represent Cuckfield, Edith Bevan was joined by Mrs Goldring, and Miss Ivy Turner, Secretary of the Cuckfield Improvement Association of which Richard Bevan was President and Treasurer, and elder daughter of Augusta Turner, widow of solicitor Montagu Turner, of Hortons, Whitemans Green. The Misses Spooner, Mrs Martindale and Miss Frank represented Haywards Heath, and the Rev and Miss Keightley came from Lindfield. Marian Verrall, 'a lady of much talent and persuasive power as a speaker', was in the chair, and conveyed a message of support from Mrs Benson, of Treemans, and apologies from Marie Corbett. Mrs Martindale urged all present to 'worry Mr Asquith with postcards'.[21]

According to Millicent Garrett Fawcett, no fewer than 4,000 public meetings were held during the four months between July and November in support of the Conciliation Bill. The *MST* of 23 August 1910 reported three such meetings. An 'influential gathering' in the Parish Room at Hurstpierpoint, presided over by Mrs Keatinge, supported by Miss Basden and Miss Duncan, numbered men among its participants: Arthur Weekes JP, of the Mansion House, and Mr Canniford, of Hassocks, both members, like Edith Payne and Miss Spooner, of the Cuckfield Union Board of Guardians. Miss Potts, of Banchory, had agreed to become Hon. Secretary to the 'embryonic' Hurstpierpoint branch of the Women's Suffrage Society.

In Haywards Heath, Mrs Sibley and her daughters of Albion House, 'long noted for their sympathy with progressive movements', hosted a garden party to which mothers and children were invited, 'for it is not the wife of every working man who can afford to pay someone to look after the children for an hour or two while she obtains a little change of air and thought'. Good weather 'enabled the company to partake of tea in the open, little tables being placed here and there about the lawn, and over the teacups friend chatted with friend about

the latest phases of the women's suffrage movement and other matters which concern the welfare of women'. While the children enjoyed playing on the swings, 'familiar names' were among those who assembled for the meeting, chaired by Miss Bryan, of Brighton: Mrs William Stevens, Mrs Martindale, Miss Frank, Miss Duncan, Mrs Goldring, Miss Little of High Croft, Haywards Road, and the Misses Spooner. Also recognised by the reporter were Mrs Fred Miller, wife of the well-known watercolour artist, who lived in Sydney Road, and her daughter-in-law, Mrs Douglas Miller, whose husband had a prestigious photography studio in Boltro Road.

Edith Bevan was accompanied by her Polish sister-in-law, Stanislawa, wife of her artist brother, Robert. An artist herself, Stanislawa had designed and painted a banner for the Society. This was displayed on the platform to much applause and she was thanked by both Miss Bryan and Miss Spooner. 'The Society would be proud to have it carried in the great processions organised in connection with the cause so dear to their hearts.' Perhaps Stanislawa had taken some practical tips from the article, *On Banners and Banner-Making*, written by NUWSS executive committee member, Mary Lowndes, for the magazine, the *Englishwoman*, of September 1909, and reprinted as a pamphlet by the Artists' Suffrage League, of which Miss Lowndes was Chairman.

Miss Margaret Ashton, the first and only woman on Manchester Town Council, and on holiday in the south of England, made a speech urging women to do their utmost to get the Conciliation Bill made law. Miss Duncan stated that a Men's League for Women's Suffrage was being started at Hurstpierpoint, and that Haywards Heath ought to be able to follow suit.

In Cuckfield, an evening open-air meeting was held in the King's Head yard just in time to be reported the next day. It was chaired by Eric Stevens, son of Mr and Mrs William Stevens, a law student training to enter his father's firm, and himself a local Liberal officer. After speaking himself on the Conciliation Bill, he introduced the

guest speaker: again Margaret Ashton, who illustrated her speech by reference to the cotton industry. The concluding resolution was carried by a 'considerable majority' and Edith Payne thanked not only Miss Ashton but also the audience for 'the attentive and courteous hearing they had given her'.

Margaret Ashton, whose 'boundless energy' was admired by Millicent Garrett Fawcett, was spending her holiday working hard. The next week's *MST* reported her 'rousing speech' to a meeting held by the CCSWSS in the Hassocks Assembly Room. It was chaired by fellow Mancunian, Mr WP Adleshaw JP. Dr B Michell Young, of Hassocks Lodge, Mr Canniford and Mr Puttick also participated, and apologies were received from Mr GF Mowatt JP, of Keymer, and Arthur Weekes. Margaret Ashton dwelt at great length on inequalities as regards employment, even in Government service, and referred to the Conciliation Bill as a compromise, acceptable for the time being. The resolution in support was moved by Mr Canniford and seconded by Dr Michell Young who said that it had long been his opinion that every woman who owned property or earned her own income and paid rates and taxes should have the vote.[22]

As part of Suffrage Week, the NUWSS held a rally of fifteen branch societies in the Albert Hall on 12 November in support of the Conciliation Bill, two days after a WSPU mass meeting in the same location. However, as the constitutional crisis regarding the composition and powers of the House of Lords had not been resolved, another General Election had to be called, and the Conciliation Bill remained shelved. In reaction to this news, WSPU members raided the House of Commons, leading to a clash between about 500 suffragettes, the police and the watching crowd. This lasted several hours and led to over 100 arrests, many injuries and two deaths.[23]

Millicent Garrett Fawcett and Bertha Mason, NUWSS Parliamentary secretary, wrote to the *Times* to explain NUWSS policy: candidates

who were in favour of women's suffrage would be supported, regardless of party.[24] In the event, the December General Election left the position of the parties little changed. Henry Cautley's return occasioned the first portrait photograph to appear in the *MST*.[25] (10 December 1910)

In January 1911 a personality who was to become an internationally known preacher addressed a CCSWSS afternoon meeting in the Queen's Hall. Miss Maude Royden, the daughter of a Baronet, was an Executive Committee member of the NUWSS. She was the author of *Votes and Wages: how Women's Suffrage will improve the economic position of women*, a pamphlet published by the NUWSS, and in 1912 was to become editor of the *Common Cause*. In 1917 she would become Assistant Preacher at the City Temple, and in 1929 would inaugurate the official campaign for women's ordination by founding the Society for the Ministry of Women.

To the *MST* reporter the 'large attendance' at this meeting was an indication of much local sympathy with the movement. He must have been relieved that Maude Royden's speech 'was not a long one', although it was 'far above the common level' as she was a 'lady of culture with ideals and the power of enlisting the sympathies of others'. She emphasized the religious side of the suffrage movement, citing the Church League for Women's Suffrage, and corresponding societies formed by the Free Churches, the Roman Catholic Church and the Society of Friends. That evening she went on to speak in the Hassocks Assembly Room, supported by the Rev. Claude Torry, Rector of Streat, by Mr RH Pott, of the London Men's League for Women's Suffrage, and by Mr Canniford. Two points made by Mr Pott must have been particularly appreciated by Edith Bevan: when he spoke of the discrimination from childhood between boys and girls and asked, "Where are the Winchesters and Etons and Rugbys for girls?", and when he claimed that in only two of the London hospitals were women allowed to work on the same footing as men. 'In other hospitals they were allowed to was the floors, to cleanse the

sores, and sometimes, as a great privilege, to superintend the stores.'[26]

Mr Canniford officiated at another CCSWSS meeting in the Queen's Hall, Cuckfield, three weeks later. Regretting that, although there was 'a large attendance', more men were not present, he introduced the Rev. C Hinscliff, Hon. Secretary of the Church League for Women's Suffrage. 'His sympathetic remarks concerning poor, overworked women made a deep impression' and drew approbation, expressed in a 'homely fashion' and with a 'directness of style', from Mary Cooper, widow of the Canon Cooper. Women with the power of thinking must be up and doing to improve the position of their suffering sisters.[27]

Rather more light-hearted evenings, however propagandist in intention, were provided by the Sussex Suffrage Amateurs, and their leading light, Miss Chute Ellis, at that time living at Lower Rookery, Ditchling. They performed plays written for the Actresses' Franchise League, for example by actress- turned- playwright Cicely Hamilton, co-founder, in 1908, of the Women Writers' Suffrage League. Their theatrical entertainment in the Parish Room at Horsted Keynes in February comprised three short pieces, *A Change of Tenant*, and Cicely Hamilton's farce, *How the Vote was Won*, in addition to *Man and Woman*, the plot of each being recounted in detail in the *MST*.[28]

At an evening meeting in the Parish Room, Hurstpierpoint, in March, Arthur Weekes, presiding, expressed disappointment that the Conciliation Bill had not been passed. Lloyd George had contended that it would be better to hold out for universal suffrage but Arthur Weekes did not think that there was any reason for that at present. Supporting speeches were made by Marian Verrall and Miss Chute Ellis. The latter was certain that there would less opposition to women's suffrage if people would think more. 'Some of them had in their minds an enormous amount of early-Victorian lumber.'

The very next day, 'a goodly company of ladies' braved torrential rain and a March wind to gather in the Congregational Institute at Horsted Keynes where 'their ardour and zeal for the women's cause must have been quickened by the speeches given'. The meeting was presided over by the Liberal, Lady Sybil Brassey, President of the Hastings branch of the NUWSS, and wife of the former MP for Hastings. She was supported by Lady Betty Balfour, wife of Arthur Balfour, Conservative Prime Minister 1902-5, representing the Conservative and Unionist Women's Franchise Association, and by Mrs Martindale, Marie Corbett, Flora Merrifield and Miss Meyer. Horsted Keynes CCSWSS branch members were joined by Edith Bevan, Miss Spooner, Ivy Turner and other representatives from Cuckfield, Haywards Heath and Lindfield. Lady Brassey declared that the leisured woman who claimed not to want the vote had got everything she wanted without it and did not realise what it meant to her less fortunate sister. Those present needed to help in the process of education by organising lectures, to be printed and circulated. During the summer she hoped to organise lectures herself in that part of the world. To the militant-minded that might seem a very tame campaign but she hoped that the slower way would be surer. Lady Balfour pointed out that the Conciliation Bill was a modest one, only intended to do for women what the 1867 Bill had done for men: enfranchise women householders who paid taxes. However, it was bound to lead to adult suffrage. Flora Merrifield, in seconding the vote of thanks moved by Cicely Corbett, remarked that 36 Town Councils had passed resolutions in favour of women's suffrage.[29]

At a public meeting and social entertainment held by the CCSWSS at the Co-operative Hall, Haywards Heath, at the end of March, red, white and green rosettes were much in evidence. After a pianoforte duet performed by professional pianist Mrs Douglas Miller and by Miss LE Peerless, 'the well-known Brighton speaker' Mrs Francis was introduced by Mr CD Wheeler of Lindfield. She complimented the Co-operative movement, saying that there were no more intelligent bodies of women to be found than in the Co-operative Women's Guilds. The Co-operative Movement differed from the

state inasmuch as it tried to put down sweating, raise the status of women, and it gave its women votes. No mention of women's suffrage had been made in the most recent King's Speech yet there was urgent need to reform laws affecting women: women should have equality with men in cases of divorce, and a man should not be allowed to die and leave everything to a cats' home and nothing to his wife.

A second interlude of entertainment was provided by Mrs Douglas Miller, giving a comic recitation, and by Miss Bannister, and Miss Hilda Wearn. In proposing a vote of thanks, Douglas Miller pointed out that votes for women could not be granted until the veto of 600 peers had been curtailed. It was announced that the Cuckfield branch now had 300 members; the Haywards Heath branch, of which Miss Messieux of Oakdene, Paddockhlall Road, had become Hon. Secretary, boasted 90.[30]

Mrs Dengate, whose husband, a teacher at St Saviour's College, Ardingly, was shortly to become Assistant Curate at Slaugham, chaired 'most ably' an At Home held by the CCSWSS in Cuckfield's Queen's Hall at the end of April. Introducing Miss Martin, Organising Secretary of the Conservative and Unionist Women's Franchise Society, she emphasized the need for laws to improve the condition of poor working women and for the vote to enable women to right their wrongs. Miss Martin, 'for the benefit of those who were just beginning their political career', explained the law-making process. The Conciliation Bill would not give working women the vote except in a very few cases but it would be the thin edge of the wedge, and in a very few years it was hoped that working women would have a voice in the government of the country and in law-making. Tribute was paid to Edith Payne's successful efforts in presenting a suffrage petition and securing the Cuckfield Urban District Council's adoption of a resolution in support of the Conciliation Bill. Mrs Goldman, of Lucastes Avenue, proposed a hearty vote of thanks for the public-spirited way in which she worked for Cuckfield, as had her mother before her. They were proud of the

fact that they now had a woman on the Council and were very grateful to those Councillors who supported the resolution. Its action had been a great encouragement to so many of them at Cuckfield.

Meanwhile, in London, the South of England was represented at the National Convention of the NUWSS by Margery Corbett Ashby, the Corbetts' married daughter. This drew up a National Memorial presented to Mr Asquith on 3 May, two days before the re-introduction in the Commons of a redrafted Conciliation Bill, asking for 'facilities' for the Bill. The new bill passed its second reading but again the Government postponed proceeding towards legislation, referring it to a Committee of the Whole House.[31]

Later in May Miss Spooner was among the participants in a conference of the Co-operative Women's Guild in Haywards Heath where Miss M Ward spoke on *Women and the State*. She did not sympathise with partial measures. What she advocated was universal adult suffrage. The thick edge of the wedge would have more chance of success than the thin edge. Although a majority of 167 had voted in favour of the Conciliation Bill on 5 May, it was making no progress and it was unlikely to be passed unless it was made a more democratic measure by amendment.[32]

'The women who want the Parliamentary vote cannot be accused of inactivity. Wherever they think they can win support, there they go, and, having gained recruits, they do their best to keep their enthusiasm at full glow.' So began a report that the Suffragists had been 'trying their luck at fashionable Lindfield'. 'It must have delighted their hearts to see gentlemen as well as ladies present.' The two major political parties were represented by those officiating: Lady Betty Balfour and Chairman Marie Corbett, who was standing in for Muriel, Countess de la Warr, daughter of Lord Brassey, and was able to announce Lord Brassey's recent conversion to the cause. "We are not rivals," remarked Miss Spooner, "but sisters working for the same cause."[33]

As sisters working for the same cause, the NUWSS and the WSPU jointly organised the Women's Coronation Procession 17 June 1911, the most spectacular and representative of all the mass demonstrations in the suffrage campaign, and intended to rival the official Coronation Processions on 22 and 23 June from which suffrage campaigners had been excluded. Millicent Garrett Fawcett claimed that 40,000 took part. This was the first and only instance of all suffrage societies appearing together and the NUWSS participation was controversial. The CCSWSS is not recorded as having been represented. Edith Bevan is likely to have been prevented from attending by her father's central involvement in Coronation celebrations in Cuckfield.

The *MST* report, although only appearing under miscellaneous *Notes and Comments*, must have made absentees wish that they had been there.

> The longest and most representative of any Suffrage Procession, leaving Charing Cross Embankment and walking by Pall Mall, St James' and Piccadilly to Kensington and the Albert Hall, included all the English, Irish, Scottish and Welsh societies – constitutional and militant – and delegates from the Colonies and many foreign nations. The procession was five miles long, and the women, all dressed in white, marched seven abreast.
>
> Following the WSPU, headed by Mrs Pankhurst, and the Pageant of Famous Women, came the red, white and green of the NUWSS led by Mrs Fawcett, Lady Frances Balfour, Lady Scott Moncrieffe, Lady Beatrice Kemp (whose husband, Liberal MP Sir George Kemp, had introduced the second Conciliation Bill in Parliament on 5 May), Madame Jeanne Schmahl (founder of the Suffrage Movement in France), and a number of other distinguished English, foreign and Colonial women.
>
> A remarkable feature of the NUWSS Section was a series of over 80 specially designed banners, each bearing the name of one of the Municipal Councils which had petitioned the Prime Minister in favour of the Conciliation Bill.
>
> Next came the Industrial working women under their own colours, then the Oxford and Cambridge University women, who no right to wear caps

and gowns, then the Graduates Union, principally composed of members of the younger universities in caps and gowns. One of the largest contingents was the Conservative and Unionist Women's Franchise Association. If Mr HS Cautley MP values peace of mind, he will see to it that has the Suffragists with, and not against, him at the next election in the East Grinstead Division. (*MST* 20 June 1911)

7

Sweated Industry

The following month, good weather permitted the second annual meeting of the CCSWSS to be held in the grounds of Hatchlands where Edith Payne welcomed over 100 members from Cuckfield, Haywards Heath, Burgess Hill, Hassocks, Hurstpierpoint, Horsted Keynes and Chailey. Marie Corbett, presiding, said that the suffragists' position had been immensely strengthened by Mr Asquith's definite pledge to grant full facilities next session for the Conciliation Bill. The report showed the Society's health and vigour. Membership had risen from 160 to over 300, grouped in the four branches of Cuckfield, Haywards Heath, Horsted Keynes and Hurstpierpoint. Meetings held numbered 26 and representatives had attended processions at London, Portsmouth, Guildford and Brighton. Although the Cuckfield Urban District Council had passed a resolution in favour of women's suffrage, the less progressive Haywards Heath Council had rejected the local suffragists' petition. Henry Cautley, however, had been persuaded by a delegation to refrain from voting against the Conciliation Bill.

Mrs Francis Carey, of Lea Copse, Burgess Hill, pointed out that the Workmen's Compensation/Insurance Bill, introduced in May by Lloyd George, ignored the interests of women. This was the subject

of much debate nationally, and a House of Commons Committee was drafting amendments intended to safeguard women's interests. Meanwhile, a lengthy article in the *Times* had explained the shortcomings of the bill as regards women,[34] and subsequent letters included an exposition by Mrs Margaret (Ramsay) Macdonald of the bill's failure to meet the needs of working women and its exclusion of married women.[35] This was followed a few days later by a letter signed by Millicent Garrett Fawcett, and by Lady Selbourne and Betty Balfour of the Conservative and Unionist Women's Franchise Association, and others, describing the bill as a scheme chiefly designed for men, and asking if anyone could seriously think that such proposals would have been made had women had votes.[36]

The Hatchlands meeting closed by resolving to change the name of the Society for the second time: to the Central Sussex Women's Suffrage Society, as its work now extended to the whole constituency.

The following evening, from a cart serving as platform, Edith Payne presided at an open-air meeting held in the yard of the King's Head at the bottom of Cuckfield High Street. Edith Bevan, Mrs William Stevens, Marie Corbett, the Misses Spooner, Katherine Gray and Miss Priestman of Warden Court, Miss Messieux of Paddockhall Road, Mrs Goldring and Mr and Mrs Hunt were there to support her. 'Miss Corbett was the star speaker, and very ably did she hold forth, never for a moment being at a loss for words. Questions were invited but there was no one bold enough to make enquiry.'[37]

Both sides of the question, however, were heard at an evening debate, between men, arranged by Mrs Carey at the St John's Institute, Burgess Hill. Mr Leonard R Burrows presided over a large audience. Mr Theodor Guggenheim, of the Men's League for Women's Suffrage, was opposed by Mr A Maconachie of the National League for Opposing Women's Suffrage. Edith Bevan and Flora Merrifield joined Mrs Carey on the platform. Each participant in the debate spoke three times, as was recorded in detail, and the

laughter and applause recorded in response to Mr Maconachie's remarks anticipated the inevitable defeat of Mr Guggenheim's resolution.[38]

The CSWSS was able to retaliate. The *MST* of 3 October carried a notice of a meeting to be held at 8.15 that very evening at the St John's Institute. Lord Robert Cecil KC, of Chelwood Gate, active in the Men's League for Women's Suffrage, and a member of the 1910 Conciliation Committee, was to speak; Countess Brassey would be in the chair. 'Carriages 10pm.' It was explained that the Conservative Lord Robert Cecil was one of 24 MPs who were to ballot for the Conciliation Bill at the opening of the 1912 session of Parliament, and that his speaking at Burgess Hill that evening, and the generous help he had given the cause, had earned the gratitude of all Suffragists.

The following week the *MST* allocated three full-length columns to the report of this meeting. 'The capacious assembly hall at St John's Institute was crowded with people of both sexes.' Flora Merrifield, Edith Bevan and Mrs Carey were again on the platform. Mrs Carey hoped to receive names of men and women with a view to forming a branch of the Central Sussex Women's Suffrage Society in Burgess Hill. Lord Robert Cecil began his long speech by observing the great changes that were occurring in public attitudes.

> There was a Debating Society connected with his profession, the law, the habit of which was to have ladies' nights. It used to be common on those occasions for the youthful lawyer to indulge in such efforts of wit and humour as he could muster. The subjects were not serious. Now women no longer cared to attend debates of that kind, and if the Debating Society wished to attract a female audience it had to provide something serious and solid for the ladies to listen to, just as if they were men.
>
> That very day the *Standard*, one of the big London daily papers, had devoted two pages to the question of women's franchise and the interests of women. They could all remember, and still see, the kind of thing the newspapers used to think good enough for women: little discussions on dress, or, if it was an advanced paper, some topic like literature or art.

37

Refuting all the usual anti-suffrage arguments, he listed women doctors, teachers, trade unionists, and women's political organisations and almost all the biggest Borough Councils and City Corporations, as bodies which had passed resolutions in favour of suffrage.

Later in the month the East Grinstead Women's Suffrage Society, at a Friday evening public meeting in the Queen's Hall there, welcomed the Prime Minister's promise of facilities the next session for the Conciliation Bill, and Henry Cautley was called upon to support it in all its stages. However, despite his earlier assurances, he was known to be unsympathetic and, as in Cuckfield, and with the exception of Lord Robert Cecil, leading figures in the EGWSS were likely to be Liberals and/or Congregationalists: the Liberal agent and member of East Grinstead Urban Council, Edward Steer; the Chairman of the local Liberals, John King of Stonelands, West Hoathly; the Buckley family of the Grange, Crawley Down; the Rev. Rupert Strong of Hammerwood; the retired Rev. Biddell; and Rev. Brack of Ardingly, a fellow-Guardian of Uckfield Workhouse with Marie Corbett.

In November 1911 Asquith said that the Government would introduce a measure for universal male suffrage exclusively but that this would be open to amendment in the interest of women's suffrage. Suffragists knew that such an amendment would have to be introduced by a private member, and that only a Government bill would have any chance of success. The violent militant reaction to this news took the form of attacks on property, the defacing of buildings, and the breaking of windows of shops and government offices, including those of No. 10 Downing Street.

The *MST* of 28 November printed a statement issued by the Executive Committee of the NUWSS distancing itself from militancy:

In view of the recent disturbances and of the threat of future disturbances of like nature, the NUWSS appeals most strongly to all suffragists both inside and outside the House of Commons to remember that such outbreaks injure women far more than anyone else and are organised by one Society only of the many existing women's suffrage Societies. The NUWSS would remind politicians that the excesses of a few men have never been held sufficient excuse for not granting much-needed and long-delayed reform, and that the best way of rendering them harmless and futile is to co-operate with those who are prosecuting this reform by constitutional and democratic methods. The NUWSS is carrying on a great constructive campaign in the country and appeals to all suffragists who are determined to secure the enfranchisement of women in 1912 to come to its support.

Throughout the winter of 1911-12 the NUWSS and its branch members continued to work to promote the Conciliation Bill. At the beginning of December, Edith Payne presided over a Friday evening annual meeting of the Cuckfield, Haywards Heath and Lindfield Women's Liberal Association at Cole's Room, Sussex Road, Haywards Heath. 'Much information on a well-worn subject was imparted', Miss Fielden pleaded for 'fair play all round', and a resolution was passed calling on Henry Cautley to do all in his power to ensure the enfranchisement of women in 1912.[39]

That Henry Cautley would do so was doubtful. A meeting he held soon afterwards was described in a letter to the *MST* from 'an enquirer':

If I were not a believer in women's suffrage, I should have been converted to the cause at a political meeting recently held in Cuckfield. Mr Cautley, in speaking on the Insurance Bill, drew attention to the maternity benefit in a way that could not fail to arouse a coarse laugh from some of the audience. He went on to say that the compulsory insurance of servants made him for the first time almost inclined to reconsider his well-known antagonistic attitude to women's suffrage. This statement evoked a burst of direful laughter from those present. Such a frivolous treatment of a serious question affecting a voteless class leads a thoughtful man to enquire whether, if women were enfranchised, their interests would not receive more suitable treatment from the speaker and his audience.[40]

This was a reference to the provisions in the Bill, currently receiving its Royal Assent, relating to domestic servants. The *Times* reported that MPs were being overwhelmed with letters and communications from constituents about this issue,[41] and suffragists themselves were divided over it. Henry Cautley must have been thinking of prominent women's franchise activists who opposed the levying of contributions from employers: Lady Willoughby de Broke and Laurence Housman had been among those attending a recent protest meeting,[42] and Lady Brassey and Lady de la Warr had taken part in a deputation to the Chancellor of the Exchequer.[43] Millicent Garrett Fawcett, on the other hand, had been one of a long list of professional women who signed a plea, published in the *Times* of 6 December, for the inclusion of servants in the Bill.

One can only wonder what Edith Bevan's position on this issue might have been. A reminder of her social standing at this time was an invitation to all, issued by the Cuckfield Improvement Association, to attend a ceremony at 3 pm on Wednesday 6 December. This was the planting, by 'Cuckfield's Grand Old Man, Mr RA Bevan JP', of a commemorative oak tree, on the corner of Broad Street and Courtmead Road, described by Richard Bevan in his speech on the occasion as the 'finishing touch' to Cuckfield's celebration of the Coronation of George V the previous 22 June.[44]

A festive CWSSS meeting at Hurstpierpoint later in the month offered a programme of seasonal songs, as well as speeches by the Rev. Torry and by Miss Chute Ellis, who was encouraged to see so many men present. She begged them to give the question of women's suffrage their very serious attention. If they took the question to heart, thought about it seriously and looked at it fairly and squarely, they might possibly say they did not like it, but they would agree that it was absolutely fair and they would vote for it.[45]

At the very beginning of 1912 Millicent Garrett Fawcett felt able to conclude her *Women's Suffrage, a Short History of a Great Movement* with an equally optimistic exhortation:

> We are on the eve of the fulfilment of our hopes. The goal towards which many of us have been striving for nearly half a century is in sight. I appeal to each and all of my fellow-suffragists not to be over confident, but so to act as if the success of the suffrage cause depended on herself alone. And even if our anticipated victory should be once more delayed, I appeal to them again not to despond but to stand firm and fast, and be prepared to work on as zealously and as steadfastly as of old.

At the end of February 1912 the *MST* reported a debate on electoral reform between the Haywards Heath Liberal Club, 'the precincts of which are usually sacred to those of the masculine persuasion', and the Central Sussex Women's Suffrage Society. This had been instigated by Mr and Mrs William Stevens and it was their son, Eric, who opened the debate by proposing that citizenship, rather than property, be the qualification for electoral rights. 'The worship of property was a form of heathenism which was very rampant in this country and ought to be done away with.' An amendment, that women should be included in the Parliamentary franchise, was moved by Mrs Dempster, the NUWSS organiser for Sussex, Surrey and Hampshire, who said that 'those ladies who were in a higher station of life, and who did not need the vote so much as others did, felt that in raising their sisters they would raise their brothers as well'. Supporting contributors included Douglas Miller. Those remaining to be convinced included his fellow Boltro Road professionals, Messrs Bradley and Vaughan, property agents. Nevertheless the motion was carried.

A particularly ambitious project now undertaken by Edith Bevan, helped by Miss Chute Ellis, was the staging of an Exhibition of Sweated Industries at Haywards Heath Public Hall in South Road. In May 1906 the *Daily News* Sweated Industries Exhibition, 'the actual processes demonstrated by workers in full view of visitors' (according to its advertisement in the *Times*[46]), in the Queen's Hall,

41

Regent Street, had led to the formation of the National Anti-Sweating League, and this organisation staged another such exhibition at the first ever Women's Labour Day convened by the Women's Trade Union League and the Women's Labour League at Earlscourt in July 1909. Edith Bevan's event had the patronage of the Princess Munster, of Maresfield Park; the Countess Brassey; Muriel Countess de la Warr; Lady Robert Cecil; Lady Cowdray; Lady Katherine Morgan, of Honeywood House, Dorking; Lady Leigh Pemberton of Abbotsleigh, Wivelsfield; Lady Kleinwort, of Bolnore; and Mrs Benson. The opening ceremony, presided over by Marian Verrall, was performed by Lady Willoughby de Broke, supported on the platform by Lady Leigh Pemberton, Marie Corbett, Mrs Martindale, Flora Merrifield, Miss Potter, of the National Anti-Sweating League, and Miss Chute Ellis.

Its shocking effect on the *MST* reporter was evident:

> The large number of fashionable folk who visited the exhibition of sweated industries . . . must have felt very sad as they gazed upon the careworn faces of the six poor women from the East End of London who were giving a demonstration of sweated work. A large card was at the back of each worker, and terrible indeed was the information set down in black and white. The cards ought to have had deep black borders - for such would have made those who gazed at them realise that the shadow of death was over the workers.

The details given on the cards were reproduced: the rates, the time taken to make each article, the length of the working day, weekly earnings and expenses: for the production of bows for babies' shoes, nursery shoes, ladies' underskirts, knickerbockers, Vesta matchboxes and artificial flowers. Further details of the making of boy's knickers, men's coats, skirts, and white blouses with twenty tucks, were cited by Marian Verrall, who also quoted an Inspector's report that six hours after giving birth a woman had resumed work with her needle. Miss Potter pointed out that young children, returning from school, often had to help their mothers in their work.

Lady Willoughby de Broke suggested that 'people of leisure might try and take more interest in the condition and life of poor workers.' To applause, she declared that she was 'an enthusiastic suffragist, and believed in women's suffrage because it was a very practical means of getting better conditions of life for women workers, the nation's most valuable asset, the mothers of the race '. Boys and girls should be educated so as to become skilled and efficient workers and all trades not actually harmful should be thrown open on equal terms with men.

The event continued into the evening with a lantern lecture given by Mr H Evans, Government Inspector of Workshops, who added to the list of sweated objects: ladies' belts, feathers dressed for tooth quills, scrubbing brushes, paper bags and confirmation wreaths. Miss Spooner led the questioning. When asked "Can a lady possibly know that she is purchasing sweated goods?" the lecturer replied, "Fortunately for their peace of mind it is absolutely impossible for ladies to know."

The same edition of the *MST* carried a report of a Liberal Club meeting, chaired by Douglas Miller, and addressed by Cicely Corbett, speaking in favour of universal suffrage. 'Her speech was fluently and charmingly delivered, and, from the outset, when she expressed her strong disapproval of militant tactics, she held the attention of her hearers.' The recent Exhibition of Sweated Industries at Haywards Heath, had brought to public attention this 'fault of the system'. Among those who participated in the ensuing discussion were Messrs Bradley and Vaughan, and others present included Marie Corbett, Miss Spooner, and Mrs Fred Miller.[47]

Later in March the younger generation of the Horsted Keynes branch of the CSWSS, with Miss Martindale presiding, hosted a lantern lecture by Cicely Corbett contrasting conditions in countries where women have suffrage with sweated industries in this country. The working costume of pit-brow girls, who screened the coal brought up from the pits for dirt, 'caused some amusement'.

43

Progress being made locally, in education and the raising of awareness, deserved all the more credit given the background of developments in the capital. The outbreak of militant window-smashing in the West End was fuel for the anti-suffragists, and the Conciliation bill was defeated in the House of Commons at the end of March. This led the NUWSS to set up an Election Fighting Fund, to support the Labour candidate in any constituency where the Liberal did not commit himself to women's suffrage. At its 1912 Conference, the Labour Party resolved to promote adult suffrage and to oppose any bill excluding women.

8

Continuing Press Coverage

In June, the third annual meeting of the CSWSS was held in the grounds of Hatchlands. It was chaired by the Rev. E Cresswell Gee, who, before his recent move to Twineham, had been working in Camberwell. The year before, in a lecture at Hurstpierpoint, he had advocated women's suffrage to raise the status of impoverished women, and ensuing correspondence on this subject with a Hurstpierpoint resident had been quoted in the *MST*.[48] He was also associated with the London Children's Country Holiday Fund, on behalf of which he and his wife tried to persuade parishioners to offer hospitality. The first point he felt obliged to make on this occasion was that, in attending the meeting, he in no way represented his brother clergy or the Church of England. 'He only wished he did!' He supported the CSWSS, in a personal capacity, because it was non-militant. Seven years spent working in the Old Kent Road district of London had exposed him to all the great social problems

of the day, the most evil of which was women's sweated labour. The 'terrible facts' he related regarding poor pay made several members of the audience cry "Shame!". He approved highly of the women's suffrage movement because he wished to see women able to help their sisters who wanted their help.

The theme of underpaid work was taken up by guest speaker Lady Frances Balfour, and also in the report of the year's activities. The most important event, 'in addition to the usual suffrage propaganda', was stated to be the Exhibition of Sweated Industries.

The meeting was given an encouraging membership update: Cuckfield 100; Haywards Heath 105; Horsted Keynes 80; Hurstpierpoint 47. Reference was made to Marie Corbett's new branch in East Grinstead. Mr Canniford paid tribute to the Chairman, saying he wished that other members of the Church of England took the same view of women's suffrage as did Mr Gee.[49]

The local Liberal Party continued to proclaim its support of the cause of women's enfranchisement. At a garden party at Franklyns in July 1912, hosted by Mr and Mrs Augustin Spicer and presided over by William Stevens, prominent Haywards Heath personalities present included Mrs Fred Miller and Mrs Douglas Miller. Mrs Ernest Miller, of the family furniture and removals business on Haywards Heath's Broadway, was also 'worthy of mention'. Speaker Marie Corbett 'said she was heartily tired of the struggle to secure the enfranchisement of women and she wished she could see the end of it'. She urged all present to write to Henry Cautley about the latest Reform Bill's exclusion of women in its proposed extension of the franchise, and advocated increased support and membership of the NUWSS. She successfully moved a resolution, to be sent to Prime Minister Asquith, stating that 'no Reform bill can be satisfactory that does not include the enfranchisement of at least a proportion of duly qualified women'.[50]

The same edition of the *MST* reported the CSWSS Saturday afternoon garden party a few days later at Lea Copse, Burgess Hill, presided over by hostess Mrs Carey. The formation of a Burgess Hill and Ditchling branch of the CSWSS was proposed by Miss Chute Ellis. In this she was supported by her brother, Burgess Hill resident Lieutenant-Colonel WE Chute Ellis, much-travelled Boer War veteran, and for 30 years a supporter of women's suffrage. As Hon. Secretary of the Burgess Hill, Hassocks and Hurst division of Lord Roberts' National Service League, Lt-Col Chute Ellis was very active himself as a local propagandist, being associated in this role with Richard Bevan, who was Chairman of the Haywards Heath and District NSL.

The afternoon concluded with a display of Morris dancing by schoolgirls directed by Miss Bonavia Hunt, the daughter of the Burgess Hill vicar. She was soon to become the leader of the new Burgess Hill branch. Leading figures turned out again a few hours later for an evening open-air meeting near Barclays Bank in Church Road. This popular meeting-place was conveniently near the station, the bank being one of the branches opened by Barclays throughout the area served by the railway network

A meeting of the CSWSS at the end of July took the form of a garden party at Knowles Tooth, Hurstpierpoint (now the Chichester Diocesan Association for Family Support Work residential centre), home of Mrs Darby. 'The broad-minded and esteemed Rev. E Cresswell Gee, genially presided.' He cited Australia and New Zealand as exemplifying the benefits of women's suffrage, the Temperance cause being one that had particularly gained. Miss Chute Ellis led the applause for his speech. 'It was a treat to meet with a man so full of moral courage. They were tired of wobblers.' In her own speech, referring to much-publicised suffragette action, she stressed that the NUWSS was 'absolutely non-militant' but 'that it was thwarted justice that was causing militancy'.[51]

Soon after this, having become close friends of Edith Bevan and other Cuckfield suffragists, Miss Chute Ellis and Susan Armitage, moved from Lower Rookery, Ditchling, to Cuckfield, taking over Mrs Goldring's house, Woodlands, next to Denman's Motor works. Susan Armitage's niece and nephew, Molly and Kevin Wakefield, who had been left motherless, lived with them and Molly attended Warden Court Young Ladies School, just across Broad Street, run by the Misses Gray and Priestman. The Wakefield children would go up Horsgate Lane and through the fields to play with Halyska and Bobby, the children of Robert and Stanislawa Bevan, when they were staying at Horsgate with their grandfather.

Central Sussex suffragist strength was by no mans concentrated in Cuckfield, however. On 5 November the *MST* announced that a deputation to Henry Cautley was taking place that day at the House of Commons, led by Lady Robert Cecil. It was to include, among others, Marian Verrall, and Mr William Wood, Chairman of the Hurstpierpoint Conservative Association. They were to go on to attend a mass meeting organised by the NUWSS in the Albert Hall that evening. 'Contingents from the National Union of Women's Suffrage Societies, which now cover every constituency, will be present.'

Towards the end of November, the Haywards Heath branch held 'another very successful meeting' in the Co-operative Hall, Sussex Road. Despite it being a Thursday afternoon, 'all classes of society were represented'. 'Cups of tea and cakes were handed round before the business arranged was started, and this gave opportunities for friendly talks.' The business arranged consisted, first, of the well-known duologue by dramatist Evelyn Glover, *A Chat with Mrs Chicky*, the most popular play in the Actresses' Franchise League repertoire, and 'simply bristling with irrefutable Suffragist points'. Miss Chute Ellis played the role of a char, arguing the cause with her employer's anti-suffragist sister, played by Miss Edith Arnold. Marian Verrall then spoke about the Reform Bill's inadequacies, and her 'recital of ill deeds done to women so moved her hearers that

cries of "Shame, shame" and "Hear, hear" reminded one of the House of Commons'.[52]

On 7 January 1913 the *MST* reported that 'all supporters of the principle of women's enfranchisement (those who advocate militancy excepted) are concentrating their forces upon an effort to ensure the deletion of the word *male* from the first clause of the Reform Bill'. This amendment, moved by Sir Edward Grey, one of the chief advocates of women's suffrage in the Cabinet, was to be supported by 'influential members from all parties in the House', including Lord Robert Cecil. Three possible versions of the amendment were to be moved. The first would give women the vote on the same terms as men. The second would give the vote to women over 25 who were owner occupiers or the wives of men thus qualified. The third would give votes to women on the basis of the Local Government register. 'If the two wider amendments fail to pass, any Member who votes against the third will prove himself an anti-Suffragist, for it is better for a few women to be enfranchised than no women at all.'

The following week a letter was printed from Gertrude Harris, of Winkfield Cottage, Ardingly Road, Haywards Heath, a member of the Haywards Heath branch, appealing 'to the electors of this country for help and support at this crisis of our movement for political liberty'. She pointed out that 'for 45 years English women have been asking to be recognised as citizens' and beseeched 'every man who believes in the principle of equal justice for men and women' to write to his MP requesting him to support one of the amendments.

However, under the headlines *Exit the Franchise Bill* and *Premier's New Pledge*, the *MST* of 28 January 1913 explained that, the day before, because the Speaker of the House of Commons had told Mr Asquith that the introduction of women's suffrage would necessitate the withdrawal of the existing Bill and the introduction of a new one, the anti-suffrage Mr Asquith moved that the Bill be withdrawn, and pledged that in the new session a private member's Bill on women's

suffrage would be given as much time as any Government measure. Lloyd George added that if such a Bill were passed by the Commons and rejected 'elsewhere', it should be sent up again and again if necessary and passed under the Parliament Act.

Militant activity continued. 1912 had seen attacks on London mail and three suffragettes, one suffering from curvature of the spine and one in an invalid chair, were found guilty of placing 'deleterious fluid' in pillar boxes at Blackheath and Deptford. The *MST*, in quoting the Recorder at the Old Bailey, intimated its own sympathy: the convicted were misguided and mistaken but were animated by the highest and purest motives, having spent many years among the poorest class of women and observed the miseries of the sweating system that led to the degradation of women and other results too terrible to contemplate.[53] The next month, following attacks on buildings, including Selfridges, 'window smashers' were arrested and Mrs Pankhurst was imprisoned.[54] The arson campaign reached its peak in 1913 and a 'suffragette arsenal', containing wirecutters, firelighters, and other destructive implements and materials, was discovered under the floorboards of artist Olive Hockin's studio in Notting Hill.[55] Suffragettes succeeded in 'capturing' the Monument and flying their banner from the viewing platform at the top, before being evicted by the police. Police were also called into action closer to home, to terminate a meeting of 'militant suffragists' on Brighton seafront, attacked by an angry mob.[56] Nevertheless, under *Seven Good Reasons why Men should support Women's Suffrage*, an appeal was made to male readers to join the Men's League for Women's Suffrage or the Men's Political Union for Women's Enfranchisement.[57]

At a meeting in the Queen's Hall, Cuckfield early in February, chaired by Mr Canniford, those present included the Rev. Brack, and several members of the Cuckfield, Haywards Heath and Lindfield Women's Liberal Association: Mrs Cleare, Mrs William Stevens, Mrs Huckett, wife of the Rev. Huckett, a former missionary, of Broad Street, Cuckfield, Miss Chute Ellis, Edith Payne and her

mother's cousin, Ellen, who lived at Landcroft, Broad Street, and Mrs Maddock. Among others present were, Katherine Gray, Mrs Dengate, Augusta Turner, Miss Goldring, Mrs Waugh, whose solicitor husband was Clerk to the Cuckfield Urban District Council and the Poor Law Board of Guardians, and Mrs and Miss Darby. Although Edith Bevan was away, visiting her brother Herbert and his family on Vancouver Island, she was represented by her elder, married sister, Maud Owen, who lived in London but was staying at Horsgate to see to the running of the house.

Disappointment was expressed that nothing had been achieved during the current session of Parliament. The guest speaker, the Rev. Canon JHB Masterman, Rector of St Mary-le-Bow, London, admitted that 'women's suffrage was losing round rather rapidly just now'. Referring to 'children born in the unhealthy slums of our great cities', he said that the community was something to which they all had a duty, and not something from which they merely derived special privileges, and every woman should take her share in deciding every vital question in that community. Women who were against having the vote had a kind of intellectual indolence. It meant a challenge to their disinterestedness and their care for other people. It was not so much a question of what women were going to get as what they were going to give. He urged his audience to ask themselves whether they supported the movement because it was the fashion or as the result of definite moral conviction. It was a moment of challenge. They must not think, however, that any means were justifiable that helped on the cause. Belief in that idea had done infinite damage. Let them resolve that they would come through with untarnished hands even if the fight took longer to win.

The supporting speech by Miss Chute Ellis was 'full of ardent devotion to the cause'. She too loathed militancy and considered it a tactical mistake of the most appalling nature. The attitude of the majority of men was expressed in 'their horrible superior smiles'. Women needed intelligent sympathy. This question was not a thing to be turned away with a shrug of the shoulders. The resolution

carried, that the Government should fulfil its pledges by giving every facility during the coming session for the enfranchisement of women on a broad and democratic basis, was to be sent to the Prime Minister, to Sir Edward Grey and to Henry Cautley.[58]

The following week, under the headline, *Advice to Suffragists: Keep Pegging Away*, the *MST* reported the annual meeting of the Cuckfield, Haywards Heath and Lindfield Women's Liberal Association at the Co-operative Hall, Haywards Heath, chaired by Ellen Payne. Mrs Spalding quoted Ramsay MacDonald, Chairman of the Parliamentary Labour Party, on the need for women's minds and experience directly to influence the legislation of the country, and begged her listeners not to allow indignation at the tactics of the militants to weaken their determination. Miss Chute Ellis, 'whose way of looking at things always commands attention', said that they needed to be 'tremendously energetic', should try and get men to their meetings, rather than nag or scold, to persuade them to see things from a woman's point of view. It would not be through violence or militancy that the women's cause would triumph. It was miserable for women to try and get the vote through breaking windows.[59]

A week later readers were reminded that this personal conviction accorded with the official policy of the NUWSS, membership of which was now increasing at the rate of 1,000 per month. A letter to the *Times*, written by Millicent Garrett Fawcett, was quoted fully. Ever since 1908, NUWSS speakers had been protesting against violence as a means of political propaganda. However, equally detestable was the personal violence, such as forcible feeding, suffered by the militants.[60]

At its annual Council meeting at the end of February, the NUWSS reiterated its opposition to militant action, but took drastic action of another form itself. Because of the collapse of the Reform Bill in January, it decided to withdraw its support from Liberal candidates in three-cornered constituencies and to concentrate its funds and

energies on the defence of Labour seats and the support of Labour candidates approved by the NUWSS Executive. At its 1912 Annual Conference, the Labour Party, thanks to Philip Snowden, had resolved to oppose any Franchise Bill which did not include women. Tried and faithful friends in the Liberal ranks would not be opposed, but NUWSS policy was now to eliminate from the Cabinet all Anti-Suffrage ministers, this being the reactionary element preventing the Liberals from giving women the vote. The new policy might result in help being given to Conservative candidates but only if they supported women's suffrage.[61]

Still pursuing its programme to establish branches in the villages throughout its area, the CSWSS held a meeting in March in the Congregational Hall in Horsted Keynes. It was chaired by the Rev. Brack, who paid tribute to Marie Corbett when he spoke of his experience as chaplain to a workhouse 'where the only visitor who really understood how things went on was the one lady Guardian'. Mrs Rica Timpany, former NUWSS Secretary, and, now that she had moved to Preston, Secretary of the branch there, reiterated Millicent Garrett Fawcett's condemnation of all violence, on the part of both the militants and the authorities, and explained that the NUWSS was now working for a Government measure rather than yet another Private Member's Bill.[62]

The Burgess Hill Pleasant Wednesday Evening Society arranged a gathering the following week at the Grove Road Schoolroom, chaired by Lt-Col Chute Ellis, and addressed by his sister on *Woman's Place and Power in the State*. Her brother, in support, cited the skill and bravery of women nurses in the South African war, and pointed out that sweated labour had been abolished in New Zealand since women had been granted the vote there.[63]

In Haywards Heath, however, even the Liberal and Radical Club could demonstrate just how deeply entrenched men's attitudes were. A report the very next week, headlined *Shall Women Have the Vote – Haywards Heath Liberals Answer, "No, No!"*, hailed Douglas Miller

as the only supporter of the cause. He had initiated a debate by proposing, 'That this house is of the opinion that a Parliamentary franchise should be extended to women on the same terms as its is, or may be hereafter, granted to men'. By giving women the vote the State would greatly benefit and both sexes would reap great advantages by being able to work together in the political field. The laws relating to marriage, divorce, inheritance, children and employment wanted drastic alteration in women's favour. Moreover, the competition with women in the labour market brought down the level of men's own wages.

The motion was opposed by Dr Seymour Pembrey, of Mount Pleasant, Scaynes Hill, who claimed that women did not want the vote. The female membership of the Anti-Suffrage Society greatly outnumbered those in support of the franchise and the large majority of women did not bother their heads about it at all. The women who wanted votes were highly-educated with private means and nothing to do. Working women had too much to do to go about agitating and having undignified fights with constables. Citing countries where women had the vote, Finland, Norway, Australia and New Zealand, Dr Pembrey declared that wherever women dabbled in politics they neglected their real duties, looking after the home and children. 'What would be the benefit of their wives arguing over politics? When they went home tired at night it would simply be a nuisance!' Fellow-reactionaries were Mr George Clarke, Mr R Leach and Mr RM Ogilvie of Haywards Road. Poor Douglas Miller was alone in voting for his own motion. 'Evidently local Liberals have no mind to submit to *petticoat government.*'[64]

Elsewhere in the constituency men could be more enlightened. In the same month the East Grinstead Men's League for Women's Suffrage was formed by Charles Corbett, Edward Steer, the Reverends Strong, Brack and Biddell, and Lord Robert Cecil, among others.

A paragraph headlined *Parliamentary Bills in which Women's Opinion is Needed*, even if a direct transcript of a NUWSS press

release, left no doubt as to the *MST*'s own stand. 'People who can still go on asking why women want the vote should consider the list of Bills before Parliament in this session.' Among current Bills requiring such consideration, apart from those to do with the franchise, were measures dealing with Cottage Homes for Aged Persons, Housing of the Working Classes, Illegitimacy and Maternity, Divorce, Elementary Education of Defectives and Epileptic Children, Employment of Children, the Admission of Women to the Legal Profession, Nurses' Registration, Mental Deficiency and Vaccination. 'A perusal of the list might help to make clear why two Bills deal with the question of Women's Enfranchisement and why two petitions in favour of women's suffrage, representing 100.00 women suffragists (not counting the followers of Mrs Pankhurst, who alone are responsible for all the acts of violence which have stained the Suffrage Cause), have been presented to Parliament during the last few days.'

Printed immediately below this was a report of the defeat, by 47 votes, of the Suffrage Bill introduced by WH Dickinson, proposing the enfranchisement of women householders over 25 years of age and of those whose husbands were householders. This proved that a Private Member's Bill, as a substitute for the amendments to the Government Reform Bill withdrawn in January, was doomed to failure. The debate had not been free: only one Cabinet member spoke on each side, although Mr Asquith was outnumbered in the Cabinet by suffrage supporters Lord Haldane, Sir Edward Grey, Mr Lloyd George, Mr Augustin Birrell and Sir Rufus Isaacs. Suffragists in the constituencies, by scrutinising the voting lists, would be able to test the honour of local MPs who had declared themselves in favour of Women's Suffrage.[65]

In June, Lt-Col and Mrs Chute Ellis hosted a garden meeting at St Margaret's, their home in Burgess Hill. Lt-Col Chute Ellis spoke of 'the hard knocks the cause of Women's Suffrage had of late received', of the help it now needed, especially from men, and of how his experience, in South Africa and in London, had allied him to

the cause. He introduced his sister, 'well-known in the neighbourhood', who spoke in her turn 'with her usual vigour and earnestness'. Refuting the suggestion that all work for suffrage should cease until militancy was stopped, she pleaded for harder work than ever before.

As if to illustrate Miss Chute Ellis' argument, printed alongside the report of this meeting was an instance of *Injustice to Wives* remarked upon at the Marylebone Police Court: the provision in the Married Women's Act requiring a wife to leave and live apart from her husband before she could take legal proceedings against him for neglecting to provide reasonable maintenance for her and her infant children.[66]

The emphasis Miss Chute-Ellis always placed on the spiritual aspect of the movement was commended by Mrs Bonavia Hunt at the Burgess Hill meeting, and this was also the theme of a garden meeting, reported on the same page, held at the home of Gertrude Harris and her sisters, to found a branch of the Church League for Women's Suffrage. The national League had been in existence for about three years and Miss Constance Harris would take on the role of Hon. Secretary of the Mid Sussex Branch. After 'a dainty tea', Miss Meyer took the chair to introduce guest speaker Rev. FH Green, Vicar of St Mark's, Tolkington Park, London. He set out the League's reasons for adopting the principle of equality in voting rights. Women who did not want the vote, and would not learn to want it, were most in need of it, for they were slaves, not only in status, but in their souls also.

On 4 June Emily Davison, who had been the first suffragette to set fire to pillar boxes, threw herself under the King's horse at the Epsom Derby, dying from her injuries on 8 June in Epsom Cottage Hospital. A spectacular and much-photographed funeral procession was organised in London by the WSPU. In the aftermath of this, the fourth annual meeting of the CSWSS, was held in the Queen's Hall, Cuckfield, inclement weather preventing it from taking place in the

grounds of Hatchlands. The large attendance included the Misses Payne, Edith Bevan, Mrs William Stevens, Mrs and Miss Huckett, the Rev. and Mrs Maddock, Katherine Grey and Miss Priestman, Miss Bonavia Hunt, Mrs and the Misses Harris, Miss Meyer, Mrs Cleare, Mr and Mrs Canniford, Mrs and Miss Darby, Miss Mertens and Miss Spooner. Marian Verrall, in the chair, presented the annual report. Membership stood at over 350, with Cuckfield and Haywards Heath each boasting over 100 members, Horsted Keynes nearly 90, and Hurstpierpoint nearly 50. As regards Parliamentary measures, most recently the Dickinson Bill, 'We regret to say that Mr Cautley, the Member for this division, cast his vote against the Bill.' The NUWSS now numbered 411 branches, 100 more than the previous year, with a total membership of nearly 42,500, an increase of 12,000. New branches were being formed all over Sussex. Although this Society was non-political, it welcomed the formation in Lindfield in April of a North Sussex Branch of the Conservative and Unionist Suffrage Society.

'We again wish to thank the local Press for the good reports they have given of our meetings.' The report of this meeting, headlined *Full of Life and Energy*, now listed all the officers appointed: Marian Verrall remained Chairman; Edith Bevan made up for absence earlier in the year by agreeing to continue as both Hon. Secretary and Treasurer of the CSWSS as well as Secretary of the Cuckfield branch. Her father had audited the accounts. Cuckfield was represented on the Committee by Edith Payne, Mrs Stevens, Ivy Turner and Miss Chute Ellis; Haywards Heath by Mabel Harris, Mrs Payne (Edith's sister-in-law), Miss Gates and Miss Spooner; Horsted Keynes by Miss Meyer and Miss Grace Clarke; Hurstpierpoint by Miss Darby and Mr Canniford. Marie Corbett was co-opted.

Guest speaker, the Rev. C Fleming Williams, of London, dwelt on the spiritual significance of the suffrage movement. Delay in the triumph of their cause they must not misconstrue into defeat. Referring to 'the Epsom incident', he said that he was acquainted with women who were not militants who were exhibiting as heroic

qualities as could be exhibited by any woman who went to prison for some daring deed. Flora Merrifield then explained the proposed pilgrimage to London from all parts of the country. It was to be an act of devotion on the part of law-abiding Suffragists to the work handed on to them by the men and women who had begun it all over 50 years before, and the sign of their unalterable determination not to cease from pressing their claim to the vote by every lawful means in their power until the vote was won. They wanted numbers and hospitality and money. Mr Canniford, proposing thanks, looked forward particularly to the housing question being 'forced to the front' once women had the vote. 'The awful conditions under which many of our poor had to love made it impossible for them to grow up spiritually-minded.'[67]

9

The Brighton Road Pilgrimage

The Great Pilgrimage for Women's Suffrage, in July 1913, was planned months in advance and involved Women's Suffrage Societies from 17 large cities, all over England and Wales, marching into London along eight main routes. On 13 June the *Common Cause* began publishing maps of the routes to London from all parts of the country, some requiring up to a fortnight's marching, although Pilgrims could join en route and travel on horseback, by carriage, motor or bicycle. No special uniform had been designed, but Pilgrims were asked to wear plain grey, white, black or navy in order to display NUWSS colours most effectively. Hats should be as simple as possible and trimmed with ribbon or raffia cockades in red, white and green. The wearing of a Pilgrimage badge was obligatory. Pilgrims were also urged to purchase, ready-made or ready cut-out, a

haversack designed for the event, with the name of their route printed on it, to be worn with the NUWSS colours across the shoulder. Posters, to be placed on London buses and tube lines, handbills and leaflets had been printed in abundance.

Appropriate clothing advertised in the *Common Cause* included hard-wearing hosiery, and readers were recommended to patronise Swan and Edgar, one of the West End businesses attacked by WSPU window-smashers, who were 'specially catering for useful articles of attire for the Pilgrimage', as could be seen in the accompanying half-page advertisement. Their ribbons in NUWSS colours, in two widths, were ideal for trimming hats and for sashes. Their walking skirts were designed to be flattering.

Advice was also given regarding stout footwear and sustaining food, and a Sub-Committee was appointed to select, from the large number submitted, a special Pilgrimage Song. The final choice, a new version of a song from the book of *Women's Suffrage Songs* published by the London Society for Women's Suffrage, words supplied by one reader and chorus by another, was printed on 20 June, above a notice to branch secretaries that WG Smith was supplying pure vegetable oil toilet soap, in boxes bearing NUWSS colours, for resale at a price that would augment Society funds. The remaining half of the page was taken up by illustrated advertisements for 'fashionable' bathing costumes from Debenham and Freebody and 'indispensable' satin coats from Gorringe's.

The *MST* of 8 July announced that the Women's Pilgrimage would culminate in a 'monster meeting' in Hyde Park on Saturday, 26 July, and a special service in St Paul's the following day. Those unable to walk or cycle the whole way would be welcome to join in for any distance. The aim was to travel at three miles per hour, to cover ten miles per day. The Sussex route, nearly 40 miles and one of the shortest, would be up the Brighton to London road through Burgess Hill, Cuckfield, Handcross and Crawley, then on via Croydon, Streatham Common, Brixton and Kennington. Departure from

Brighton would take place on Monday, 21 July, at 10 am, then from Cuckfield at the same time on Tuesday 22 July, and from Crawley on Wednesday 23 July. Further details could be obtained from Edith Bevan or Miss Spooner.

Edith Bevan was also busy organising a Saturday afternoon Suffragist jumble sale in Cuckfield's Queen's Hall to raise funds towards meeting the expenses of the Women's National Exhibition to be held in Haywards Heath in the autumn. This was reported in the *MST* on 15 July. 'For a few pence it was possible to get a rig-out which would make one pass for a duchess in the East End of London. There was also a great run on the boot stall.' It is unlikely that those who snatched up these bargains were equipping themselves to go on the march.

Advance publicity emphasized the ethos of the exercise as well as advertising it as public spectacle. The *East Grinstead Observer* of 19 July printed a letter from Miss Helen Hoare of Charlwood Farm, distinguishing between the NUWSS and the militants, and explaining that the former, 'to encourage its members in a long and disheartening struggle', had organised the Great Pilgrimage. 'Probably the public will never believe it, but it is a fact that not one of the very many suffragists who are taking part in either the march or in the demonstration in London will commit one single act of violence.' A similar notice was contributed to the *Brighton Herald* of the same date, giving details of the itinerary, the programme of meetings to be held en route, and the eminent speakers and participants. These would include members of the Courtauld and Rowntree families, Lady Johnston and her husband, Sir Henry, the explorer and writer, of St John's Priory, Poling, Arundel, and the well-known preacher, the Rev. T Rhondda Williams of the Union Church, Brighton.

Meanwhile, and for the second year running, Mrs Darby hosted a CSWSS garden party at Knowles Tooth, this time specifically for the Hurstpierpoint Branch. Dr Helen Boyle, pioneer psychiatrist and

Hove GP, introduced the principal speaker, her brother, the Rev. Vicars Armstrong Boyle, Vicar of Portslade and Rector of Hangleton. His long speech was followed by a few comments by Mrs Darby. 'They did not go in for fighting, smashing windows and that sort of thing but for forty years she had been a widow and paid rates and taxes, and she thought it was rather hard that she did not have a vote. Her gardener and chauffeur each had a vote, and she was very glad they had, but she would like to have one too.' The Rev. Cresswell Gee, proposing thanks, declared, as regards his ecclesiastical colleague, that he had never heard a better speech on the suffrage question, and, as regards the Chairman, that in his former work as a hospital chaplain he had come across many medical practitioners who were women. 'They were all level-headed women, too.'[68]

In another report in the same edition the *MST* made clear its sympathy. 'A woman, properly qualified, has a vote for the Parish Councillor, the District Councillor, the County, or Town, councillor. Why then should she then not have a vote for the Member of Parliament for the division in which she lives?'

This question concluded a detailed description, amplified by the *Brighton Gazette* the next day, of the Monday morning departure of about 100 Pilgrims from the Level Police Station, Brighton, wearing their distinctive red, white and green badges 'artistically placed in their hats' and matching sashes. Some carried the recommended haversacks bearing the words, *Brighton Road*. Banners proclaimed the participation of the Worthing, Littlehampton and Seaford branches as well as those of Brighton and Hove. Assembled to see the procession off was a crowd of supporters, drawn by the participation of well-known public figures such as The Hon. Mrs Alys Russell (the first wife of Bertrand Russell), of Ford Place, Arundel, and Lady Maud Parry, President of the Brighton and Hove branch, and her husband, the composer Sir Hubert Parry, of Knight's Croft, Rustington. One Pilgrim was playing a side-drum. Another played a violin to accompany the singing of the national Pilgrimage

song and of a special Brighton Road song composed by Mr Madle, organist at St Bartholomew's. A horse-drawn covered van bearing the slogan, *NATIONAL UNION OF WOMEN'S SUFFRAGE SOCIETIES NON-PARTY NON-MILITANT* carried the pilgrims' luggage and campaign literature to be distributed en route. This included a special souvenir number, in a red-printed cover, of the *Common Cause*, sold for one penny.

'They looked very fit and not a few of them looked very clever too! There were among the Pilgrims ladies holding University degrees and others noted for their work on behalf of their poor and suffering sisters.'

Led by Flora Merrifield and Lady Maud Parry and some noisy youths playing mouth organs, the marching Pilgrims were preceded by cyclists acting as scouts to warn other road users of the approaching procession. 'Motorists very considerately slowed down whenever they passed.' At a succession of stopping-places, banners were unfurled and the party was photographed by Douglas Miller, whose wife was walking from Brighton to Burgess Hill.

At Patcham, where 'the villagers were greatly interested in the marchers', a suffrage song was sung. For the 50 or so ladies who carried on from there, the two by two military style of marching could then dispensed with along the country roads. Farm labourers who stopped to watch were handed leaflets. At the lunch stop at Clayton Hill, leading into Hassocks, among the members of the Cuckfield and Central Sussex branch waiting, with their banner, to greet the procession were Edith Bevan, Miss Chute Ellis, Marian Verrall, the Misses Harris, Miss Darby, and Mrs Warren of Balcombe. Mr T Meates, JP, of Hammonds Place, Burgess Hill, was there with his motor car to offer the more tired participants a lift. Alys Russell sold copies of the *Common Cause*, 'while other ladies dismounted from their cycles and distributed Suffragist literature.'

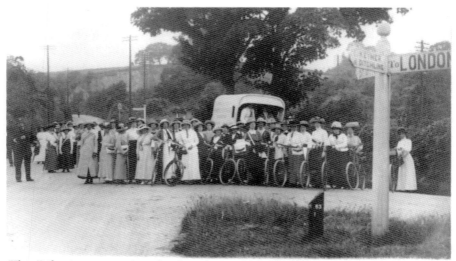

The Pilgrims stopping for lunch on Clayton Hill. In the centre foreground is Flora Merrifield. (Douglas Miller)

A welcome rest and al fresco tea awaited the suffragists at the 16th century Hammonds Place, conveniently located on the London Road, before the procession continued into Burgess Hill, where its arrival had been awaited with interest and it was joined by contingents from Newhaven and Seaford.

'At Station Road a large crowd gathered, and as the Pilgrims passed by, several women made remarks which did not do credit to their intelligence.' The location selected for the open-air meeting was under the 'Reformers' Tree', in front of Barclays Bank, 'adding one more cause to the many advocated on this spot'. Here the onlookers were most numerous. The Rev. Cresswell Gee, Mr and Mrs Canniford, Major Lang, Chief Constable of East Sussex, and numerous prominent Burgess Hillians were present: Mrs Bonavia-Hunt; the Misses Colman, of Holmesdale House, London Road; Mrs Southcott, of St Wilfrids, Ferndale Road; local lawyer Mr Lawson Lewis and others. 'Miss Bonavia-Hunt was among the cyclists who bore the suffragist colours.' Once the Eastbourne contingent had

arrived, as planned, Mr Meates, Rica Timpany and Alys Russell in turn climbed up on a cart to address the crowd. ' "We have not had a single rotten egg," she said, amid laughter. It was because they feared such things might greet them that they refrained from putting on their best clothes.' Police Superintendent Anscombe, of Haywards Heath, who was in charge of security from Clayton Hill to Crawley, was complimented on the order maintained and the arrangements he had made for the protection of the Pilgrims. Over 60 *Friends of Women's Suffrage* cards were signed, more copies of the *Common Cause* were signed, and donations were made towards funds.

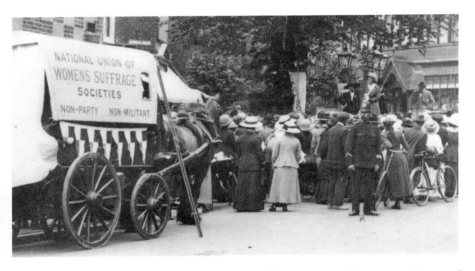

At Burgess Hill, under the 'Reformers' Tree' immediately in front of Barclays Bank, at the junction of Church Road and Station Road. (Douglas Miller)[69]

After more tea, provided by the CSWSS, at the Station Road Hall, the Pilgrims set off again at 5.15 pm. 'Some went by bicycle, some by brake, and others by motor. About a score took to the road on foot, led by Miss Bevan of Cuckfield.' Proceeding via Fairplace Hill and the Haywards Heath Road, and greeted by gatherings of

spectators along the way, the marching contingent arrived at Tylers Green at 6.30 pm. Here they were met by a large gathering of Haywards Heath and Cuckfield suffragists, including Miss Spooner, the Misses Payne, Mrs Cleare, Mrs William Stevens, Katherine Gray and Miss Priestman, and Mrs and Miss Mertens.

> The procession was re-formed for the entry into Cuckfield, which was effected with considerable show of strength and colour. The old town provided a good crowd of spectators who now and then broke into applause. The Pilgrims were preceded by their cycling corps and their drummer, and they hoisted their banners proudly. In the rear were three ladies in invalid chairs. The women sang their hymn as they marched along. At the Clock House in the centre of the town, the goal of the day, the National Anthem was sung about 7.10 pm. (*Brighton Gazette* 23 July 1913)

> Whatever views the people who turned up to see the Pilgrims out of idle curiosity held regarding votes for women, they had to admit that the suffragists before them were not such a bad lot after all. May we not hope that the literature distributed will help them to better understand the women's cause and make them also realize that the Suffragists are not *Suffragettes*?

> 'When the procession proceeded into Cuckfield people flocked to their gates or windows . . . it was impossible for anyone to stand by the Cuckfield Town Clock and to hear the Pilgims sing their song and also the National Anthem without being deeply impressed.' (*MST* 23 July 1913)

The *MST* was published on a Tuesday afternoon, and its reporter must have stopped the press, for his account of the event includes a description of the scene that very morning. After the Pilgrims had spent the night at Cuckfield as guests of the Cuckfield branch and sympathisers of the cause, some put up in the numerous spare bedrooms at Horsgate, they left for Handcross, in the rain, headed by Superintendant Anscombe. The reporter lists a large number of the more than 70 Central Sussex members who were taking part, including Marie Corbett, Louisa Martindale, Mrs Maddock, Mrs Willliam Stevens, Mrs and Miss Cleare, the Misses Harris, Miss Chute Ellis, Susan Armitage, Edith Payne, Marian Verrall, Flora

Verrifield, Miss Bonavia-Hunt and Miss Spooner. Many Cuckfield residents accompanied them for a short distance, despite the wet weather.

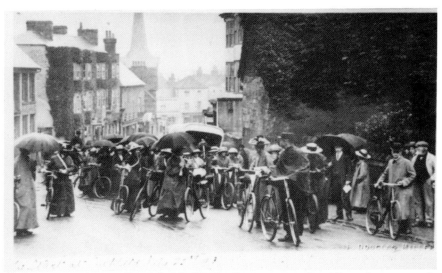

Setting off from Cuckfield High Street on the Tuesday morning. (Douglas Miller) Edith Bevan is in front, immediately behind Superintendant Anscomble, looking back to check that all are ready.

According to the next instalment of the story, in the following week's *MST*, rain had given way to bright sunshine by the time the procession stopped at Handcross for a meeting 'held under the canopy of heaven', chaired, from the wagonette platform, by the Rev. Cresswell Gee. He appealed principally to the men for support. Speeches were made by Mrs Francis and by Mrs Helena Auerbach, NUWSS Treasurer, President of the Reigate and Redhill Society, and Vice-President of the Jewish League for Woman Suffrage. The crowd, gathered to experience the first ever Suffrage meeting held in the village and less sympathetic than at Burgess Hill, eventually appeared to appreciate that this movement was non-militant. Many

agreed to sign *Friends of Women's Suffrage* cards, and the usual resolution in favour of women's suffrage was carried almost unanimously. After a picnic lunch, the Pilgrims, accompanied on foot by Mr Gordon Sloane, whose chauffeur was deployed to offer lifts, set off for Crawley, arriving about 3.30 pm. They were met by local sympathisers and escorted by the police to the Square where a song was sung and a brief meeting held. Crawley residents provided tea and overnight accommodation and turned out to an evening meeting at St Peter's Parish Hall, chaired by Alys Russell. This was so crowded that many were unable to gain admission. Over 400 people listened to the speakers, Mr Staples and Mrs Ray (Rachel) Strachey, Parliamentary Secretary of the NUWSS and daughter-in-law of Lady Jane Strachey, herself a member of the NUWSS Executive Committee. 'The utmost good feeling prevailed throughout the proceedings, there being no unruly interference and nothing of a disorderly nature', and nearly 60 more sympathisers signed up.

In East Grinstead events took a very different turn. 'The main streets were disgraced by some extraordinary proceedings on Tuesday evening.' Marie Corbett had arranged a march and public meeting prior to departing the following day to join the Brighton Road Pilgrims on the way to Horley. 'The procession consisted of about ten ladies and about 200 children who did nothing but yell and shout the whole time. . . Yells and hooting greeted the ladies throughout almost the entire march, and they were also the targets for occasional pieces of turf.' Edward Steer, attempting to chair the meeting, was shouted down by a crowd of abut 1500. The guest speaker was Laurence Housman, writer of propaganda suffragist plays, illustrator and member of the Artists' Suffrage League, and younger brother of poet AE Housman. He fared no better. The crowd continued to shout abuse and the speakers were pelted with stones, tomatoes, and eggs, 'the unsavoury odour of which became noticeable over a considerable area'. Helen Hoare was named as having been injured by being 'struck in the face by a missile of some kind'.

The ladies were invited to take shelter in Mr JB Allwork's house, but as soon as they entered, the crowd on the pavement rushed the doorway and more visitors than had been invited forced themselves in. The police eventually cleared the house and the ladies were taken out at the back and thence to their headquarters, the Dorset Arms Hotel. This was then besieged by a yelling mob of lads. 'The streets did not resume their wonted quietude until a late hour. There were many expressions of regret, from opponents as well as sympathisers, that the speakers were not given a fair hearing.'

Three such expressions appeared as letters to the editor. One, from BT Fairbridge of Fairfield, pointed out how badly it reflected on East Grinstead that 'a great writer and poet' should come down for London 'to speak upon the subject of the day', only for his voice to be drowned in the hootings and booings of undisciplined and uncontrolled children. The second letter, from 'a woman bystander', expressed surprise that not one of the men present had interfered 'to put a stop to the senseless cries of a number of small boys'. The third letter, from a 'women's suffrage sympathiser', referred to the 'total failure of the police, who were on the spot, to cope with a mob of unruly boys, who completely spoiled the meeting and disgraced the town'.

When the East Grinstead Pilgrims reassembled on the High Street on Wednesday morning, in drizzling rain, 'a small assembly gathered to see them off' and, as the 'youthful and rowdy element' was absent, speeches could now be made. Laurence Housman spoke on the civilising influence of women, the need for which had been demonstrated the previous evening. Mr Steer, apologised on behalf of the town. 'The tradesmen within the sound of his voice who had saved up rotten eggs to throw at ladies ought to be well ashamed of themselves.' The ladies, numbering about 20, then set off in cars decorated with posters and the NUWSS colours to join the Brighton Road Pilgrims and the Horsham contingent on their way from Crawley to their mid-day meeting at Horley. (*East Grinstead Observer and East Surrey Journal* 26 July 1913)

At Horley, at mid-day, the Pilgrimage, joined by several decorated motor cars, had to contend with more taunting and aggression, but a huge meeting, attended by over 3,000, despite cold wind and drizzling rain, was held early on Wednesday evening at Earlswood Common, en route to Reigate and Redhill. This was addressed by Mr Tom Richardson and Miss Fielden, from London, and followed by a service in Reigate Parish Church. Again, over 60 cards were signed and donations made. Thursday was spent marching to Purley and Croydon; on Friday the Pilgrims reached Vauxhall. Each of the eight regional contingents converging on London had been issued with its itinerary for the Saturday procession to Hyde Park. The East Coast, Kentish Pilgrim Way and Brighton Road Pilgrims assembled in Trafalgar Square at 2.30 pm, then marched via Cockspur Street, Pall Mall, Waterloo Place, and Piccadilly to Hyde Park Corner. 'They poured in from every corner of the country amidst a riot of colour and martial music. . . Hostility was disarmed, opposition melted, before their insistent proclamation that they were peaceful and law-abiding.'

Around the Reformers' Tree, 19 platforms had been erected and at 5 pm a speech was begun from each, the speakers most eagerly-awaited by the 70,000 strong crowd being Millicent Garrett Fawcett and Mrs Philip Snowden. Lady Strachey and her daughter-in-law were also among the nearly 90 speakers. The simultaneous carrying, in front of the 19 platforms, of the same resolution demanding an appropriate Government measure, was hugely cheered. Edith Bevan, Miss Chute Ellis, who had walked all the way from Brighton to London, Susan Armitage, the Misses Payne, Miss Spooner, Miss Cleare, Miss Darby, and the Misses Harris were among CSWSS members present.

The *Common Cause* deemed the Pilgrimage and its 'triumphant conclusion' in Hyde Park an unqualified success.

Those who went out to meet the Pilgrims pouring in along the great roads felt at once that it was a triumph. Whatever some of them had been through whether they had met with applause and sympathy only, or applause and abuse in turn – they all marched in so gaily and so gallantly that it seemed that they must take the world by storm.

"Whenever a hooligan throws mud or curses at me," said one of our speakers on Saturday in Hyde Park, "I always have in mind a picture of his wife, who has to bear every day what I have to bear for an hour, of insult and brutality."

The verbal and physical abuse to which Pilgrims had been subjected in the impoverished, deprived, industrial Midlands was easily understood.

We allow babies to be born in surroundings that are foul. We sweat their mothers. We give them in all their lives nothing that is beautiful. And when we want to put a beautiful ideal before them, we are met with the brutality which is the natural result of all this. Some day we hope to set ourselves to the task of reform, and make these horrors impossible. Some day men and women, working side by side in the full consciousness of their great responsibility, will be able to give to the citizens of the future a fairer world to live in.

Elsewhere, particularly in London, even in the poorest districts, the Pilgrims had met with 'nothing but enthusiasm and perfect understanding'. Idealism was undiminished.[70]

The *Common Cause* the following week printed the impressions of a roving reporter who had gone round meeting various processions as they entered London.

On Thursday I motored off trimmed up to the nines in Common Cause posters and such pretty baubles to find the Brighton Road Pilgrims, and a smart lot they were, everybody jolly and friendly round them.

But Friday night! Those who were at King's Hall in St George's Market by the Elephant will not forget how South London welcomed the Kentish Pilgrims' Wayfarers and their allies of Brighton Road. Our Bermondsey Labour friends, and the organised railwaymen in their workmanlike

uniforms, and last but not least, the drums and fifes and the gorgeous giant banners of the 'sons of toil', all there and all out to make the thing go as it ought to go. High spirits and sobriety, and sympathy and the genius of orderliness, keeping watch and ward lest the ladies should suffer discourtesy! The band played us in, and at first we thought we should never get to the speeches because everyone shouted to the challenge, 'Three cheers for the women', and we, not to be outdone in courtesy, gave 'Three cheers for our friends the Labour men'. But at last Mrs Snowden, who had with her a contingent of American friends, rose and received a great ovation.

By 15 August a Brighton Road Pilgrim had had time to compose a personal reminiscence for the *Common Cause*, starting with the Tuesday, as the first day of the Pilgrimage had received more coverage, for example in an account by a Pilgrim contributed to the Brighton Herald of 26 July.

It was still by the beautiful country roads that we made our way to Handcross, which was then introduced to a suffrage meeting, and to Crawley, where in the evening we had a crowd in the Parish Room. The suggestion of a friendly constable that we should stop at Lowfield Heath the next morning was accepted, and after speaking to villagers there, we had an impromptu meeting at Horley, where by good luck we fell in with the vicar, who 'chaired' for us, and with a lady who spoke from experience of the benefit of the women's vote in New Zealand. There were sundry interruptions from a motor bicyclist, and vague threats reached us of bags of soot being sent on to greet us on Earlswood Common. What did await us there in the chill rain was an audience of 3000, and the two impressions that remain are of the intelligent interest on some of the faces and the enthusiasm of a boy who looked after our banners and put a shilling (earned as a caddy) into our collection.

There is no space to tell of the hospitality shown – at Meresham for instance next morning – as on our whole progress. The easy 'pilgrimage order' was changed to 'procession order' for good and all at Purley when the band joined us and with banners flying we marched into Croydon and out again next day. Meetings, of course, everywhere and perhaps none more useful than that held at the dinner hour on Streatham Common, when the London Society took over responsibility.

In the four and a half days we had sold 600 copies of the *Common Cause* and distributed 10,000 to 12,000 leaflets and collected a large number of Friends' signatures. All along the road the Hon. Mrs Bertrand Russell and Mrs Auerbach were our chief speakers, and if considerations of space prevent the mention of any other names, these at least must not be omitted.

In early August Marian Verrall chaired a 'very successful' meeting of the Horsted Keynes and Danehill branch of the CSWSS at the Congregational Hall. Marie Corbett gave an account of the International Women's Suffrage Congress held at Budapest the previous month, attended by delegates from 26 countries, numbering about 3,000. Countries unable to send representatives had sent messages of encouragement. The Burgomeister, other city officials, and private residents arranged hospitality and entertainment, and delegates enjoyed specially reduced railway fares, a specially composed overture performed by the Orchestra of the Royal Theatre, and a special out-of-season production at the Opera. This inspiring report made Marie Corbett's audience feel that 'there was not time to be lost in putting one's shoulder to the wheel in helping on the cause which had so nearly reached the top of the hill'.

This 'last great effort' was the theme taken up by Miss Chute Ellis. After a long and stiff climb, it was at this stage that the pull was hardest and needed all possible strength and encouragement. One must not be discouraged or cease for one moment to undertake the final struggle which would enable the Women's Cause to reach the summit. The women present needed to pull themselves together and become energetic workers, doing their very utmost to help the Cause, which was of such vital importance to the country. 'Space forbids our recording more of Miss Chute Ellis' fervent yet amusing speech.'

This space was needed to print a notice from the NUWSS. In the aftermath of the Pilgrimage, Millicent Garrett Fawcett had led a deputation to Ramsay Macdonald to express gratitude to the Labour Party for refusing to support any further extension of suffrage to men unless women were included. His attention was drawn to the strength

of the non-militant suffrage movement. Such opposition as had been encountered by the Pilgrims was incited by anti-suffragists claiming that the Pilgrims were militants. When this confusion was cleared up, the Pilgrims were given a willing hearing. Ramsay Macdonald agreed that the Pilgrimage had done an immense amount of good in counteracting the effect of militancy upon the public mind. Support for women's suffrage was to become part of the Labour Party's coming autumn campaign.[71] A deputation at the same time to Asquith had been too disappointing to merit mention.

10

Women's Handicrafts

Throughout this period, news of the activities of the WSPU was enough to explain the repeated emphasis, by those representing the NUWSS, on the society's belief in, and adherence to, lawful methods of publicising its cause. The *MST* of 19 August reported the escape, to join her daughter Christabel at Deauville, of Mrs Pankhurst, convicted of inciting the blowing-up of a house that Lloyd George was to occupy. That a separate report, in the same edition, of a Suffragette arson attack on a school in Carnarvon, was headed *Suffragists burn school*, exemplified continuing confusion between the militants and constitutional campaigners.

At a CSWSS meeting at Ditchling, reported in the *MST* of 26 August, the three speakers, standing in a farm wagon on Pond Green, were Chairman Mr Canniford, Mrs Francis, and Miss Chute Ellis, who reminded the audience that she had lived for three years in Ditchling. An appeal was made to the people of Ditchling as 'a most intellectual set'. The emphasis was on 'trying to make a great

constitutional change in a perfectly constitutional manner', the great pilgrimage of the previous month, for Miss Chute Ellis 'the most delightful week of my whole life', being evidence of the Society's non-militant methods.

As if to serve as a reminder of traditionally-perceived gender roles, however, the display advertisement placed immediately beneath this report shows a smart gentleman, in suit and bow tie, smacking his lips over 'the most enjoyable of all dinner sweets', illustrating the headline claim, 'The *men* like BIRD'S'. The italics are original.

A single column in the *MST* of 2 September contained three distinct but related items. One referred to a report by the Medical Officer of Health for Islington on sweated industries and the ignorance of girls who went straight from school into workshop or factory without learning about housekeeping or bringing up children, with disastrous results. 'Yet there are still people who wonder why many Englishwomen are so eager to have a share in determining the course which legislation shall take in educational and other matters which concern so closely the happiness and welfare of the community.'

This was sandwiched between two items pointing the contrast between the current approaches to obtaining this share. Under *The Militant Movement*, Mrs Pankhurst was quoted exhorting her supporters to recharge themselves for renewed battle after the holiday season.

On the other hand, it was noted approvingly that the CSWSS was planning a novel exhibition of women's handicrafts to be held in the Haywards Heath Public Hall, South Road, and the nearby Church Lads' Brigade Hall, facing Gower Road, at the end of October. Competition entries were to be submitted to Edith Bevan or Miss Spooner. Attention was drawn to the advertisement placed by the CSWSS to be found in another column. This began by naming the patrons of the event, most of whom were well-known suffragists: Muriel, Countess de la Warr; Maud, Countess of Selbourne (from

Liss, Hampshire); the Countess Brassey; Lady Robert Cecil; Lady Janet Chance, who was to become known as a birth control campaigner; Mrs Benson; Alys Russell, and Marian Verrall. Others included Lady Willoughby de Broke, Lady Cowdray, and the Hon. Lady Johnstone, who, with Lady Maud Parry had been among the signatories of a letter, published in the *Times* of 12 March 1913, written to the committee representing the West End businesses vandalised by militant suffragettes. This letter deplored such lawless action but urged the committee to pursue the redressing of the militants' grievances rather than demand punitive legislation. Among the most local patrons were Lady Kleinwort, of Bolnore, Mrs Rawson of Gravenhurst, Bolney, Mrs CW Erle of Mill Hall, Cuckfield, Mrs Spicer, and Mrs Sydney Buxton of Newtimber Place, wife of the MP and President of the Board of Trade.

Three weeks later reference to the 'distinguished ladies giving their patronage' introduced a reminder in the *MST* about the event; in the adjacent column was a report of an attempt, assumed to be by suffragettes, to burn down a signal-box on the line between Three Bridges and Horley. Where editorial sympathy lay continued to be made clear: in complimenting the organisers of the exhibition, namely Edith Bevan and Miss Spooner, aided by Constance Harris, the *MST* of 4 November declared, 'It is safe to say that a more valuable and interesting collection of exhibits had never before been got together in Haywards Heath.' The long list of lenders, from the locality and from further afield, included garden designer, Gertrude Jekyll. Miss Cleare and May Caffyn led a number of instrumentalists in providing musical interludes. As a professional music teacher, who advertised lessons given at her home, Stanmer, in Haywards Road, May Caffyn had particular reason to support the demand for equality with working men. It was noted approvingly, however, that 'the occasion was non-political, it was not made use of to boom *Votes for Women* and so received the active support of many ladies not identified with the women's movement'.

Mrs Sydney Buxton, in opening the event, made a speech exhorting women to take up some form of handicraft. 'In these strenuous days, affecting the nerves of women, it was excellent to have something to do with the hands.' Joining Susan Armitage and Miss Chute Ellis among the many CSWSS members named as helping at the exhibition was Stanislawa Bevan, whose husband was himself occupied at that time with a forthcoming exhibition: at Brighton Art Gallery, of *English Post-Impressionists, Cubists and Others*.[72] Stanislawa also judged the pictures. Unsurprisingly, Miss Chute Ellis won first prize in the essay category, judged by Flora Merrifield and Mrs Francis. The title stipulated was equally predictable: *How the Extension of the Franchise to Women will Benefit the Community* – surely intended as an invitation to boom.

The communication skills for which Miss Chute Ellis was known were demonstrated again, at a November evening entertainment of music and comedy, organised by the Horsted Keynes branch of the CSWSS. When she reprised her role as Mrs Chicky, 'the get-up and realistic energy she put into the part should have convinced any *antis* amongst the audience that she had every right and all the intelligence required to speak for herself through the vote'.[73] To follow, her fellow-thespians performed *How the Vote was Won* with such 'delightful spirit and finish that they simply convulsed with laughter an audience who took up every point of a most humourous play. There should not be many *antis* left in Horsted Keynes today.'

Some weeks later Miss Chute Ellis delivered 'a capital address' to a social gathering, to which 'friends of both sexes were invited', held by the Burgess Hill Women's Liberal Association. As always she emphasized her loathing of militantism and violence, however much she might sympathise with the frustrations of those who had been driven to engage in such courses of action.[74]

11

Women's Lecture Programme

On 29 January 1914 Maude Royden, now billed as 'one of the greatest women speakers in this country', was again booked to deliver two addresses, this time titled *The Meaning of the Women's Movement*: at 3.30 pm to the Cuckfield branch of the CSWSS, then at 8.15 pm at the St John's Institute, Burgess Hill. In the event, she missed her train from London and did not reach Cuckfield until nearly 5 pm. Fortunately the meeting was being ably chaired by the Rev. Marchant Pearson, Headmaster of St Saviour's College, Ardingly, which provided 'education at a low rate to sons of persons of small means and others with limited incomes'. The meeting was 'kept going' until Miss Royden's arrival by the Rev. Pearson and by Miss Chute Ellis, 'always an interesting speaker', by Marie Corbett, 'whose manner and charm never fail to appeal', and by Miss Spooner. That Miss Royden, when she eventually rose to speak, was able to make up for lost time, is indicated by the full and lengthy reporting of her speech.

Under the chairmanship of the Rev. Cresswell Gee, and in the presence of several other local Vicars, Miss Royden rose to her feet for a second time, just a few hours later, to address Burgess Hill 'people of all classes'. Although she drew on different illustrations, her theme was the same: the need for co-operation between men and women. Again the *MST* report, in its detail, conveyed her conviction, passion and energy. Her stamina can only have been equalled by that of the *MST* reporter.[75]

Later in the month 'a very interesting meeting' was held in Balcombe, in the Half Moon Assembly Room, above the coach house and stabling across the road from the inn, to discuss the

forming there of a sixth branch of the CSWSS. 'Enthusiasm and persistency are necessary for the attainment of one's end, and it must be conceded that women who want the vote do not lack enthusiasm or stickability. Their activity is remarkable and so are their powers of persuasion.' Edith Bevan, and Susan Armitage and Miss Chute Ellis were present from Cuckfield, and Miss Spooner took the chair, saying that Sussex women were proud that their county was not behind other counties in championing the cause. 'Although there is a good deal of illness in the parish, there was a very fair attendance.' Among the Balcombe residents 'noticed among the audience' were Mrs Newton, the wife of the local doctor, of Stockcroft, Mr GJ Warren of The Gables, whose wife had taken part in the Pilgrimage, and Mr G Jupp, the landlord of the Half Moon. Alys Russell spoke on the meaning of the women's movement, 'and there was not a dull moment all the while she was on her feet'. 'Referring to the Suffrage march to London last year, Alys Russell said it was quite fashionable now to go suffrage marching. It was much better and healthier than hunting or golf.' Regarding Lloyd George's talk of building 120,000 homes, women ought to be consulted. 'The right sort of cottages would not be built until women could make their power felt.'[76]

That no branch appears to have been formed in Balcombe is perhaps attributable to the absence of the young Lady Denman, of Balcombe Place. Had she not been obliged to accompany her husband, who, as a Liberal Peer, went out to act as Governor-General of Australia in 1911, she would no doubt have been a directing force in any local suffrage organisation. With a parental background of commitment to suffrage and active membership of the Women's Liberal Association, she had herself become a member of the Executive of the Women's Liberal Association which, from 1910, refused to support Liberal Parliamentary candidates who declined to answer the Executive's test questions on suffrage, and she had advocated the curtailing of the power of veto of the House of Lords. During the month of May 1910 she had been reported speaking at the Balcombe Liberal Association, emphasizing the need for women to have the vote.[77] When she

returned from Australia in the summer of 1914, however, suffrage campaigning was about to be suspended.

It had been reported in the *MST* of 18 November 1913 that an education programme was being undertaken by the NUWSS to look at deficiencies in the State's legislation regarding women and children and in the provision of statutory care. The programme was to be delivered through the NUWSS network by its 40 trained organisers and over 100 qualified speakers. The first of a series of lectures given under the auspices of the Cuckfield Branch of the CSWSS took place in the Queen's Hall early in March. The speaker, introduced by Miss Spooner, standing in for Mrs Dengate, was Miss Anna Martin. She had worked for fourteen years at a women's centre in Rotherhithe, East London, and was the author of *The Maternity Benefit*, a pamphlet published by the NUWSS in 1911. She now spoke on *The Mother and her Difficulties: how the Law treats her*, declaring that sheltered women, who knew every comfort and luxury, needed to understand the position of those who were less highly favoured than themselves. The wages of a woman working in a factory, however low, were protected by law. However, upon marriage she gave up this legal protection, and whatever maintenance orders could be served on a weak and irresponsible husband and father were largely ineffective.[78]

Before introducing the next lecture at the Queen's Hall, Edith Payne, presiding, paid tribute to 'one of the pioneer suffragists', Louisa Martindale, whose death was a great loss to the cause. Alys Russell, founder of a maternity school at St Pancras, then spoke on the subject of neo-natal care. Since the women's movement had begun, the rate of infant mortality had declined, partly because of the schools for mothers that had sprung up all over the country. Women who could not afford to learn from expensive nurses and doctors were glad to have the education that they were not given before marriage. The present maternity schools were all private institutions but ought to become part of the educational system of the country. When women were given the vote, then, and only then, would this take place.[79]

The *MST* heartily commended this course of lectures for local women. 'The Lecturers have been ladies who hold important positions in the world and know what they are talking about.' The third in the series, on *The National Importance of the Needs of Motherhood*, was delivered by Dr Florence Willey, of the University of London School of Medicine for Women. In introducing her, Mrs Dengate, surely attempting to suggest that the talk they were to hear would be applicable to all members of her audience, commented that the maiden aunt was 'a most useful person' in helping to care for children. If it came to pass that children were kept at school until the age of 15, girls should be taught in the last year how to make porridge and simple puddings and treat simple ailments and care for children. 'The strength of the King is in the health of his people.' Dr Willey's theme was ante-natal care. This would reduce infant mortality and was essential for the health and strength of the race. 'Physical and mental development suffered through children being deprived of proper nourishment, and later in life those children swelled the ranks of the unemployable.'[80]

The final lecture, in the Co-operative Hall, Haywards Heath, was on *Woman, Marriage and Motherhood*. It was delivered by Dr Elizabeth Sloan Chesser, the feminist medical journalist, who was introduced by Gertrude Harris. Her theme was, appropriately, co-operation between men and women on the basis of equal authority and recognition, politically, legally, economically and sexually. Particular consideration needed to be given to helping impoverished widows, unmarried mothers and women wage-earners. Not only should girls be instructed in first aid, nursing and child management before leaving school, but local Mothers' Clubs might be formed, to be addressed by 'competent persons on household management and health matters'.[81]

Complementary to this education programme was the Woman's Kingdom Exhibition organised by the NUWSS as part of the

Children's Welfare Exhibition at Olympia. According to the *MST* of 31 March, it was to represent

> every phase of the manifold activities of the modern woman: her love of home joys and comforts, her care of the child, her share in the professions, in business, and in industry, in art, science and literature, her organising ability, and her part in public life. Those who wish to gain some comprehensive idea of the progress made by women in all parts of the civilised world in recent years and of the scope and aims of what is broadly known as the Women's Movement should not fail to visit this exhibition.

In May, in the aftermath of the defeat of Lord Selbourne's Women's Enfranchisement Bill, Mrs Brack held a drawing room meeting at the Rectory in Ardingly, presided over by her husband. He condemned militancy but thought that the desire of women to obtain a larger share in the direction of public affairs resulted from Christian teaching. Views as regards women were changing as part of general social change. 'A few years ago it was considered most improper for a woman to ride a bicycle, but no one thought it improper for them to do so today.' Guest speaker Mrs Francis envisaged Parliamentary franchise resulting in Acts of Parliament that would improve the position of women workers and protect children. The concluding speaker was Miss Chute Ellis who regarded militancy as a tragedy, requiring suffragists to work all the harder for the vote. She was sure, however, that the suffrage question was drawing men and women closer in comradeship and breaking down class barriers.[82]

The *MST* allocated limited column inches to instances of suffragette militancy, such as arson and the attacks on paintings in public art galleries.[83] It continued to make clear its sympathy with law-abiding suffragists. As if to reassure its most influential readers, it reported on 23 June 'a joint manifesto of protest against militancy, published by the NUWSS and the Conservative and Unionist Women's Franchise Association, which should leave no doubt in the public mind that these constitutional organisations are entirely dissociated from the policy of the WSPU'.

12

Pulling out all the stops: Millicent Garrett Fawcett in Cuckfield

Because of unsettled weather, the fifth annual meeting of the CSWSS, on 20 July 1914, had to be held in Cuckfield's Queen's Hall instead of in the garden at Hatchlands. The promise of national celebrity Millicent Garrett Fawcett drew an exceptionally large and interested crowd. Lady Robert Cecil presided, assisted on the platform by the Countess Brassey, Marian Verrall, Edith Payne and Mr Canniford. Lady Robert Cecil began by distancing herself from Mrs Pankhurst and her militants, seeing their organised attack on works of art, the property of the nation, as that most likely to disgust public opinion. As a Conservative Suffragist she admitted that the Conservative party was the most backward in the cause of Women's Suffrage, but she hoped that strong support in the Church of England would encourage the adoption of the cause.

'Miss Verrall, in moving the adoption of the annual report and balance sheet, said they must congratulate their indefatigable Secretary, Miss Bevan, on the splendid working of the Branch. (Applause).' In addition, Miss Chute Ellis having moved to Cuckfield from Ditchling, 'we congratulate ourselves on having secured her invaluable help as Hon. Organiser'. Activities during the year had included propaganda meetings at Brook Street, Handcross and Twineham, in addition to those already mentioned, and the local Press was thanked for the very full reports of meetings. Tribute was again paid to Mrs Martindale who 'laboured in the cause for nearly 50 years before the public conscience was aroused on the question of the enfranchisement of women'.

Millicent Garrett Fawcett called on whichever party was elected at the next General Election to introduce women's suffrage. The point of view of women should be considered by any government put in power. Women wished to have a voice also in the expenditure of the country, towards which, as taxpayers, they contributed. Examples of other injustices were the law's refusal to recognise a mother as the parent of her child, the difficulties being met by those attempting to have the age of consent raised from 16 to 18, and the inadequate punishment of those who committed offences against young women and girls. For her 'vigorous speech proposing a vote of thanks' Miss Chute Ellis, seconded by Mrs Dengate, 'received quite an ovation'. Mrs and Miss Cleare provided a musical accompaniment to tea, and the weather cleared to permit a stroll round the Hatchlands garden.[84]

The outbreak of war brought about a suspension of propagandist activity on the part of the NUWSS. It mobilised its forces in order to use its organisation for relief work, offering the use of its Central Office, premises and staff, at 14 Great Smith Square, Westminster, for receiving, registering and classifying offers of help, and instructing its 500 branches to offer their services to their Local Relief committees. Richard Bevan, now aged 80, former Treasurer of the Cuckfield Urban District Council, and still Treasurer of the Cuckfield Rural District Council, was one the prominent residents who attended a meeting held by the former to discuss cases of distress in the parish caused by the war. Agreeing to serve on the committee formed to raise funds, to which he himself made a substantial contribution, he would have listened to the reading of a letter from his daughter, referred to the committee for consideration, offering, on behalf of the local Women's Suffrage Society, the assistance of an organised band of women.[85] Two weeks later the *MST* reported similar action on the part of the Haywards Heath Branch of the CSWSS. It was then decided that a Women's Committee, representing all the women's organisations in the area, would achieve more. This was now to work with the War Fund Committee, the treasurer of which was Lt-Col Chute Ellis.

While, in early September, Richard Bevan joined William Stevens and other JPs and Cuckfield professional gentlemen on the platform of a recruitment meeting in the Queen's Hall chaired by Col. Stephenson Clarke of Borde Hill,[86] Edith Bevan and suffragist friends Mrs Stevens, Mrs Maddock, Katherine Gray and Miss Huckett, were among those who agreed, at a meeting at the Vicarage, to serve on a committee to arrange local accommodation for Belgian refugees.[87] In the event, the Home Office decided not to send refugees to Sussex, so it was decided that donations should be redirected to the Central War Refugees Committee.

Edith Bevan then put her nursing skills into practice in the Queen's Hall, until later in the war, when her father's deteriorating health obliged her to devote herself to nursing him. In May 1916, Millicent Garrett Fawcett, on behalf of the nearly 600 groups affiliated to the NUWSS, wrote urging Asquith to recognise women's contribution in all areas of the war effort by granting them the vote. However, it was not until the end 1916, when Lloyd George replaced Asquith as head of the wartime Coalition Government, that due recognition could be acknowledged.

Meanwhile, the Cuckfield *Parish Magazine* of August 1917 reported, 'The long continued and serious illness of Mr RA Bevan is causing grave concern and anxiety to his many friends in Cuckfield and he certainly has our earnest prayers and good wishes for his recovery.' The *MST* of 29 January 1918 carried a headline, *Mr RA Bevan's Illness*: 'On enquiry this Tuesday morning we were informed that Mr RA Bevan of Horsgate had had a good night but that his condition remained precarious.'

When the Representation of the People Act received Royal Assent on 6 February 1918, Edith Bevan was therefore preoccupied. Richard Bevan died twelve days later on 18 February, aged 84. His death was front page news in the *MST* the following day. The 'democratic sympathies' mentioned in his obituary perhaps referred to Edith's suffragist activities. His funeral was a local state occasion. Edith

Payne, Miss Spooner, and Mr Canniford, representing the Board of Guardians, Mrs Cleare, Susan Armitage, Miss Chute Ellis, Katherine Gray, Miss Priestman, Miss Huckett, Mrs and the Misses Mertens, the Rev. Maddock and Mr and Mrs William Stevens were among the many familiar names in the crowd attending. At the service the following Sunday, the theme was again the universal veneration earned by Richard Bevan and how he would be missed. The March *Parish Magazine* printed a lengthy eulogy and expressed 'heartfelt sympathy to Miss Bevan who nursed her father with unwearied love and devotion throughout his long illness'. The Board of Guardians, passing a resolution of sympathy to Edith Bevan and other members of family, recalled that Richard Bevan would donate money himself, 'Mr Bevan's half crowns', to elderly persons leaving the Workhouse, and had the seat near the Workhouse gate provided for those awaiting admission.

The Representation of the People Act enfranchised women over 30, the age qualification intended to prevent a female majority, who owned or occupied property of at least £5 annual value, in effect, householders or the wives of householders; and graduates. The vote was extended to all men, the residence requirement being rescinded as it would exclude men who were away on active service. In April, a meeting of the Cuckfield Women's Suffrage Society was held in the gymnasium of Warden Court School where William Stevens explained its principal provisions, especially as they affected women. It was estimated that men voters would be increased by two million, and that, as well as the one million women already entitled to vote in Local Government elections, five million married women would become Parliamentary electors, nearly doubling the present number of voters. Edith Bevan was unable to be at the meeting but it was reported that members of the CWSS had presented her with a silver coffee pot and milk jug in recognition of her services to the society as Hon. Secretary since the society's inception.[88]

On 28 May, under the headline, *A Splendid Ending to a Long and Memorable Fight*, the *MST* reported a thanksgiving service held in

the Congregational Church at Cuckfield, attended by Edith Bevan, Miss Chute Ellis, Susan Armitage, Edith Payne, Mrs Maddock, Mrs William Stevens, Mrs Cleare, Ivy Turner, Gertrude, Constance and Mabel Harris, Katherine Gray and Miss Priestman, and many other members of the CWSS. Miss Cleare was at the organ and the choir was composed of young ladies from Warden Court School. The Rev. Maddock conducted the service, aided by the Rev. FJ Gould, of Brighton, 'for long a champion of the women's cause', who, while acknowledging their triumph, reminded his listeners that they had not yet attained all they wanted: a woman had to be 30 to qualify for the vote; a man only 21. That would have to be rectified, but time and patience were necessary. Meanwhile beneficial changes would certainly result from extending the franchise to women – changes which would never be made all the while men only had the vote.

13

The End of the Horsgate Era

Horsgate was sold in June 1918 by Edith's eldest brother. She inherited about 11% of her father's estate and arranged to rent Chapel Farm House at East Chiltington from the Stanton/Novington estate owned by the Powell-Edwards family, setting up home there with Miss Chute Ellis and Susan Armitage.

Later that summer attended Edith the funeral of nursing and suffragist colleague Miss LF Majendie, of Barham, Cuckfield, accompanied by representatives from the Queen's Hall VAD Hospital and the War Hospital Supply Depot and Miss Mertens, Miss Huckett, Katherine Gray, Miss Priestman, and Mrs and Miss Turner. It is likely that, on 28 April 1919, she again came back to Cuckfield,

accompanied by Susan Armitage and Miss Chute Ellis, who had assisted in the Queen's Hall as VADs, to join about 50 other former hospital staff for a celebratory tea, as reported in the *Parish Magazine* in June.

Another reunion took place in November 1922 when, as both the *MST*[89] and the December *Parish Magazine* reported, Central Sussex was well-represented in the great gathering at Brighton Pavilion for a presentation by the Duchess of Norfolk, whose husband, as the Crown's representative in the county, had organised the military recruitment programme. This was of 800 Red Cross medals, specially struck, to nurses and VADs of the Red Cross Society and the Order of St John from all parts of the county, in recognition of their valuable services to the sick and wounded during the Great War. In order to receive a medal it was necessary to have put in at least 1,000 hours. Edith Bevan and suffragist colleagues Olive Turner, younger sister of Ivy, who had lost a brother, Miss Huckett, who had lost two brothers, and Miss Cooper were among the members of the Cuckfield Detachment listed.

A speech by Lloyd George, reported in the *Times* of 25 November 1911, had been prescient:

> If women by their presence on the register saved us from the infamy of a single war, they would have justified their vote before God and man. When women had got the vote, not only here, but on the Continent, he thought the mothers would see that the battlefields of Europe were not drenched with the blood of their sons.

Among other sons of Cuckfield who were lost was Eric Stevens whose pacifist convictions had led to his enlistment as a stretcher-bearer.

On 23 April 1922, St George's Day, two memorials were unveiled in Holy Trinity Church, Cuckfield. The more ornate tablet is in memory of Richard Bevan. Edith having been involved in collecting and acknowledging donations towards this and contributors had included

Mrs and Miss Cleare, Katherine Gray and Miss Priestman, Mrs and Miss Mertens, Mr and Mrs William Stevens.[90] Hugh Mertens and Eric Stevens are among the names of the 80 young men remembered on the plainer tablet.

Elsewhere in Central Sussex, too, there were suffrage activists who did not live to see women's franchise granted, or to make use of their vote. Arthur Weekes died in 1917; his eldest son was killed the following year. The Rev. Bonavia Hunt's death was announced in the *MST* on 1 January 1918, and the funeral of Mrs Benson on 25 June 1918.

A NUWSS press release appeared in the *MST* of 3 September claiming that women registering as electors in enormous numbers throughout the country. It was predicted that all sorts of interests would be eager to secure the women's votes for their own purpose, and that people who, in the old days, would never have raised their hat to the women's movement, would use their machinery now to capture the women's support. This was borne out the following October when, in preparation for the General Election that would follow the Armistice, Henry Cautley and his colleagues held meetings throughout the area with the object of forming women's branches of the local Conservative and Unionist Association, which had altered its rules to enable women to be admitted on the same terms as men .

> He urged women to learn all that they could about politics and the policy of the man they were going to vote for. At present they could not vote for a woman, but he believed that, before many years were over, they would have that opportunity. (Laughter and applause) Now that the women had got the vote, he hoped that they would give the men a good example in exercising it.

A letter, from 'a woman voter', printed on a subsequent page, complained about the way one such meeting was conducted, and showed how eager women were to inform themselves.

> I went recently to a small village gathering called to form a local Unionist Association, wishing to learn, with other women, for what cause we should give our vote. During the course of the address reference was made to the Labour Party. In scoffing tones we were told that it no longer represented Labour because brain workers were included. We wondered, 'Why not?'
>
> Women everywhere are wanting to learn. Is it not possible throughout the constituency to organise one political meeting in each place, where we could be told plainly and truthfully by a Unionist, Liberal and Labour representative for what each candidate stands? False statements could not then be made, without the possibility of refutation, and we should be given a fairer chance of obtaining the information we seek (to say nothing of the economy in lighting, labour and time resulting from the holding of one meeting instead of three). This or that party cry will not have any weight, but we do wish to give our vote in the cause of righteousness, justice and brotherhood. We earnestly desire a new England and a new world, founded on the principle of love to our neighbour and to God. Can we hope for this when one party throws dust in the eyes of another, and a network of misrepresentation is once more spread? Let us hear fairly, that we may decide according to the light given to each of us.

On yet another page of the newspaper, under the Headline, *The Labour Party Up and Doing*, was an account, written perhaps by a reporter who had attended the gathering referred to in this letter, of meeting held by the newly-formed Haywards Heath Labour Party. 'There was an excellent attendance of hand and brain workers.'[91]

In December 1918 another Coalition Government led by Lloyd George was returned. Of over 1600 candidates, 17 were women. All women candidates in England were defeated. These included Margery Corbett Ashby, who lost to Neville Chamberlain at Ladywood, Birmingham, in the first of seven unsuccessful attempts to get into Parliament. The only woman elected, for Sinn Fein in Dublin, was the Countess Markievicz, who refused to take the oath of allegiance to the King and so could not take her seat. In 1919 Nancy Astor became Britain's first woman MP, holding the safe Conservative seat in Plymouth after the elevation of her husband to the peerage. In 1928 the Equal Franchise Bill granted political equality with men, in giving the vote to all women over 21.

14

The East Chiltington Epilogue

Edith Bevan undertook extensive restoration of Chapel Farm House at East Chiltington, as Kevin Wakefield recalled:

> Part of the house was fifteenth century. Many of the walls were three feet thick and made of great blocks of Sussex marble, a hard limestone of fossil seashells. Layers and layers of old paper were removed from walls and ceilings, exposing magnificent oak beams. The large open fireplace in the living room was some six feet by five feet high. A large fire grate was installed on the raised hearth and then, as though waiting to be discovered at the right moment, in the corner of the vast orchard, overgrown with weeds and grass, was found an old Sussex fire-back.
>
> It was a massive piece about three feet by two feet and some two inches thick. Embossed across it in four-inch letters were the words *John Fuller 1606*. However, in cutting the letters into the mould backwards, he had forgotten to turn the *J* and the *N*, so that the *J* was facing the wrong way and the N had its diagonal reversed!
>
> Modern plumbing was installed, with water pumped up from the Novington stream by means of a hydraulic ram.[92]

The house is situated adjacent to East Chiltington Church with which all three women became very much involved. By 1920 they were members of the Parochial Church Council and the Vestry. From 1921 Edith, as secretary, invited the committee to hold its meetings in Chapel Farm House, presumably in the 'Common Room' where a large fireplace was the only source of heat in the house. She was later succeeded by Miss Chute Ellis as secretary, and when the latter resigned from the PCC in 1941 she was thanked for 'her many services during the past years'.[93]

According to the reminiscences of local residents, the late Mrs Rachel French and Mr Ron Page, Susan Armitage was a Sunday School teacher. A Sunday School Christmas party was held at Chapel Farm house with a Nativity scene set up in the barn. In preparation for the viewing of this, Edith Bevan would go on ahead to crank up the gramophone.

Miss Chute Ellis, who was never called by her first name, Rose, was dumpy and wore man's clothes with a collar and tie. She was a founder member of the Plumpton Women's Institute in July 1918, becoming its first Secretary, and in November 1928 was presented with a parchment inscribed by Ditchling calligrapher, Edward Johnston:

> Dear Miss Chute Ellis,
>
> We, as members of the WI wishing to shew (sic) something of our feelings of regard and of our deep debt for your unceasing work and interest in our WI, beg you to accept our small offering as a tribute of our gratitude and affection.

The names underneath include Miss Bevan and Miss Armitage. Miss Chute Ellis subsequently became President of the WI, succeeding her friend Mrs Powell-Edwards and Mrs Torry, the wife of the suffragist Rector of Streat.

Miss Chute Ellis continued to demonstrate her enthusiasm for amateur theatricals by encouraging fellow WI members to enter, with some success, annual drama competitions, held in Lewes, and in a photograph of the cast of *The Mock Trial* on stage in 1929, the elegant height and clearly-defined features of the 60-year-old Edith Bevan are still distinctive.[94]

The three women employed a maid, who wore a starched uniform, and two gardeners. The energetic Edith, known to enjoy striding along the Downs, would chop firewood herself. Edith's sister Maud

would arrive, driven by a chauffeur, to stay for the summer. Edith herself enjoyed driving a succession of Austins.

Miss Chute Ellis died in 1948. Edith was obliged to spend most of the last three years of her life caring for Maud at her home at 81 Cadogan Place, although she hated London. Maud died early in 1952, and Edith had only a few months left to spend back in Sussex before she herself died on 10 October, two months before her sister-in-law, Stanislawa. The two sisters and Stanislawa are buried in the Bevan family grave in Cuckfield churchyard.

No record has been found in Cuckfield of the five and a half years Edith Bevan spent raising social and political awareness in Central Sussex. The name of Edith Payne is better known: as a tribute to her efforts to maintain a lending library in Cuckfield, the voluntary library, run, for about 20 years in the Queen's Hall and closed recently, was named after her. Moreover, Edith Bevan is often confused with Enid Bevan, 25 years younger, and the daughter of Bertrand Yorke Bevan, a second cousin of Richard, who was also a Barclays banker and likewise established his family home in Cuckfield. Edith Bevan never made platform speeches herself at the many meetings she organised, her words being confined to business announcements, and she does not appear to have talked in later life about her contribution to this period of local and national life. However, thanks to the assiduous following of the suffragists' campaign on the part of the *Mid Sussex Times*, her story can now be told in addition to those of her father and artist brother.

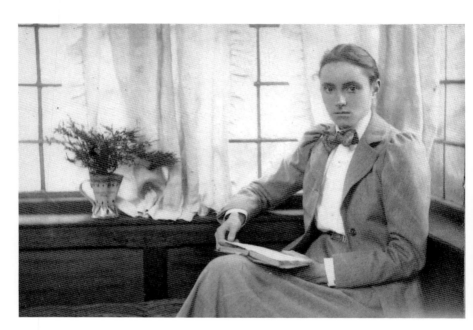

Edith Bevan

Footnotes

1 MST 7 Jan 1896: 'By invitation of Mr and the Hon. Mrs Sergison, the Crawley and Horsham Fox Hounds met at Cuckfield Park last Tuesday. Those in attendance included Miss Bevan.'
2 The Common Cause 15 July 1909
3 MST 10 August 1909
4 MST 21 Sept 1909
5 MST 16 June 1908
6 This is referred to in the 8 June 1909 MST report of the first public meeting of the CDWSS in the Queen's Hall.
7 The Common Cause 25 Nov 1909
8 MST 14 Dec 1909
9 MST 8 June 1909
10 MST 29 June 1909; MST 20 July 1909
11 MST 13 July 1909
12 MST 19 Oct 1909
13 MST 23 Nov 1909
14 MST 4 Jan 1910
15 MST 11 Jan 1910
16 MST 25 Jan 1910
17 MST 15 March 1910
18 MST 3 May 1910
19 MST 5 July 1910
20 MST 19 July 1910
21 MST 16 August 1910
22 MST 30 August 1910
23 MST 15 Nov 1910
24 The Times 30 Nov 1910
25 MST 30 November 1910
26 MST 24 Jan 1911
27 MST 14 Feb 1911
28 MST 7 Feb 1911
29 MST 21 March 1911
30 MST 4 April 1911
31 MST 2 May 1911
32 MST 23 May 1911
33 MST 30 May 1911
34 The Times 26 June 1911
35 The Times 5 July 1911
36 The Times 10 July 1911
37 MST 4 July 1911
38 MST 1 August 1911
39 MST 5 Dec 1912
40 MST 19 December 1912
41 The Times 27 Nov 1911
42 The Times 22 Nov 1911
43 The Times 27 Nov 1911
44 MST 12 Dec 1911
45 MST 19 Dec 1911
46 The Times 28 May 1906
47 MST 5 March 1912
48 MST 28 March 1911

49 MST 25 June 1912
50 MST 16 July 1912
51 MST 30 July 1912
52 MST 26 Nov 1912
53 MST 14 Jan 1913
54 MST 25 Feb 1913
55 MST 25 March 1913
56 MST 22 April 1913
57 MST 18 March 1913
58 MST 11 Feb 1913
59 MST 18 Feb 1913
60 MST 15 Feb 1913
61 MST 4 March 1913
62 MST 11 March 1913
63 MST 18 March 1913
64 MST 25 March 1913
65 MST 13 May 1913
66 MST 17 June 1913
67 MST 24 June 1913
68 MST 22 July 1913
69 See *Bygone Days in Burgess Hill*, Mark Dudeney and Eileen Hallett, Mid Sussex Books 2003, p20: according to a note on the back of one copy of the photograph, P.C. Foot is on duty.
70 The Common Cause 1 August 1913
71 MST 12 August 1913
72 It was from this exhibition that Robert Bevan's painting, *Cab Yard, Night* was purchased for the Brighton Art Gallery collection. A member of the Fine Art Sub-Committee, advising Director Henry Roberts, was William Stevens.
73 MST 2 Dec 1913
74 MST 2 Dec 1913
75 MST 3 Feb 1914
76 MST 24 Feb 1914
77 MST 3 May 1910
78 MST 10 March 1914
79 MST 24 March 1910
80 MST 7 April 1914
81 MST 28 April 1914
82 MST 12 May 1914
83 Evelyn Manesta and Lillian Forrester attacked paintings of beautiful women in Manchester Art Gallery at same time as Mary Richardson slashed Velasquez' *Toilet of Venus* in the National Gallery (19 March 1914).
84 MST 21 July 1914
85 MST 18 August 1914
86 MST 8 Sept 1914
87 The Cuckfield Parish Magazine Nov 1914
88 MST 16 April 1918
89 MST 7 Nov 1918
90 WSRO 301/4/12
91 MST 22 Oct 1918
92 written account passed to the author by Mrs Rachel French via Miss Powell-Edwards
93 ESRO PCC minutes PAR 293/14/1/1,2,3
94 ESRO WI scrapbook 62/3/1

Unless otherwise stated, quotations from Millicent Garrett Fawcett are from MG Fawcett, *Women's Suffrage, a Short History of a Great Movement*, The People's Books, TC and EC Jack 1911

Acknowledgements

Nickola Smith, creator and first Hon. Curator of Cuckfield Museum, generously allowed me to study the material she had put together for her exhibition, *Votes for Women*, at Cuckfield Museum 20 March – 20 May 1997, to coincide with the General Election on 1 May of that year.

While Hon. Curator myself of Cuckfield Museum, I was involved in the inception of Shirley Bond's research project on the 80 Cuckfield servicemen who were killed in the First World War. The product of this, her book, *Cuckfield Remembered*, 2007, provides further information about families mentioned here, and rewards cross-referencing.

The photographs of Edith Bevan are from the collection of the Baty family, descendants of Robert Bevan, and additional pictures and reminiscences can be found in the family history written by Edith's niece, Dolby Bevan Turner, a copy of which is in Cuckfield Museum.

For talking to me about the ladies of Chapel Farm House, I remember with gratitude the late Miss Auriol Powell-Edwards, Mrs Rachel French and Mr Ron Page, with whom I enjoyed conversations in October 1995.

My thanks are due also to Joan Dutton, of Balcombe, to East Grinstead Museum, to Burgess Hill Library where the archived *Mid Sussex Times* can be studied on microfilm, to East Grinstead Library, to Haywards Heath Library, to the *Mid Sussex Times* for authorisation to quote extensively and for the Douglas Miller photographic images, and to Helena Wojtczak of The Hastings Press for advice.

Bibliography

Shirley Bond *Cuckfield Remembered* 2007

Elizabeth Crawford *The Women's Suffrage Movement in Britain and Ireland, a Regional Survey* Routledge 2006

MG Fawcett *Women's Suffrage, A Short History of a Great Movement* The People's Books, TC and EC Jack 1911

Julie Holledge *Innocent Flowers, Women in the Edwardian Theatre* Virago 1981

M Pugh *Women's Suffrage in Britain 1867-1928* Historical Association pamphlet 1978

Constance Rover *Women's Suffrage and Party Politics in Britain 1866-1914* Routledge and Kegan Paul 1967

Frances Stenlake *From Cuckfield to Camden Town, the story of artist Robert Bevan* Cuckfield Museum 1999, and *Robert Bevan, from Gauguin to Camden Town*, Unicorn Press 2008: see *Bevan family and Cuckfield* section of bibliography here

Lisa Tickner *The Spectacle of Women, Imagery of the Suffrage Campaign 1907-14* Chatto and Windus 1987

Helena Wojtczak *Women of Victorian Sussex* Hastings Press 2003; *Notable Sussex Women* Hastings Press 2008